CERAMICS

1921-1941

BARBARA IFERT

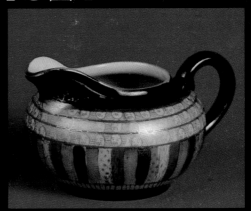

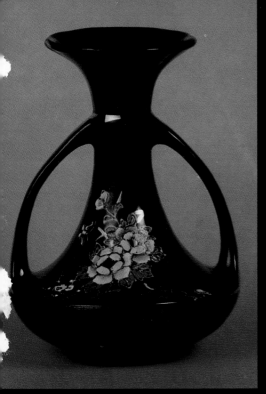

WITH PRICE GUIDE

Schiffer Publishing Ltd

77 Lower Valley Road, Atglen, PA 19310

Dedication

To my son Jim, who can always be counted on for a word of encouragement, a solution to a problem, and a reason to smile when my spirits droop. While I was writing this book and became frustrated over whether to call those large and small covered containers "cookie jars" or "cracker jars", his suggestion to call them "bait buckets" and "cricket boxes" was purly inspiration, only a *true* fisherman would have thought of it! Thank you, Jim, for all your help and good cheer; thank you, Susan, for sharing him; and thank you both for the light of my life, my grandson, Scot.

A very warm and loving thank you also to my son Don who helped in so many ways that I lost count. Those delicious snacks you provided when the photography sessions ran into the wee hours of the morning were a life saver!

Copyright © 1994 by Barbara Ifert
Library of Congress Catalog Number:
94-65618

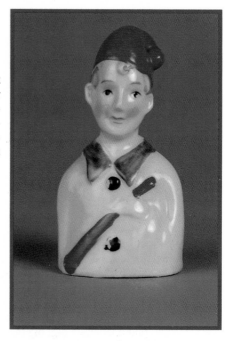

Printed in Hong Kong
ISBN: 0-88740-613-0

We are interested in hearing from authors with book ideas on related topics.

Would you guess that this 4-1/2 inch clown is a bell? There are always surprises when you collect "Made in Japan" items.

Published by Schiffer Publishing Ltd.
77 Lower Valley Road
Atglen, PA 19310
Please write for a free catalog.
This book may be purchased from the publisher.
Please include $2.95 for postage.
Try your bookstore first.

Contents

Acknowledgements

 Sincere gratitude is extended to all of you wonderful people who offered encouragement, and scouted flea markets and shows to find "Made in Japan" items for me: Maurice Smith, who went with me to countless flea markets, garage sales, and auctions and only asked "What am I doing here?" a half dozen times; Eileen Sloan, who went "antique-ing" with me on so many occasions; Bob Mogle, who read the manuscript and gave invaluable suggestions; and that one special lady, Sarah Aaron, who spent hours helping me double check the captions and photo labels--a big, big thank-you! With all your enthusiastic help, compiling this book has been a pleasure and a memorable experience.

 A special acknowledgement and "thank-you" to the following people who loaned their "Made In Japan" articles to be photographed: Sarah Aaron, Katherine Alexander, Lisa Brunner, Vernelle Doran, D. J. Edwards, Virginia Eglen, Nancy Griggs, Don Ifert, Mildred Kemmer, Phyllis Lyons, Faith Moss, Steve Peterson, Pendleton Antique Mall, Bob Post Antiques, Safron Post, Helena Reed, Sandy Seay, Eileen Sloan, Ruby Sloan, and Maurice Smith.

 A special note of appreciation to my photographer, David Edwards. We worked some long and tedious hours and he never lost his patience or his sense of humor--Thanks, Dave.

Preface

If you love old majolica but find it increasingly difficult to find or too expensive, look at the "Made in Japan" variety of majolica, circa 1921-1941. It is quite affordable and some pieces are even prettier than European and American majolica. While some authorities may not perceive these "Made in Japan" pieces as "true majolica," more and more collectors are adding modern majolica items to their collections simply because they love the majolica look regardless of who made it or when it was made.

Admire Royal Bayreuth? Consider those "Made in Japan" tomato-shaped creamers, sugars, teapots, pitchers, and the charming little mustard jar. The price tags on genuine Royal Bayreuth are pretty steep for the average collector, but the "Made in Japan" version is still reasonably priced. A nice collection is possible with just a little patience and perseverance.

For centuries, potters have copied other potter's wares, often adding their own special touches to make their versions unique. The Japanese are no exception. You will find "Made in Japan" articles that mimic Royal Doulton, German snow babies, and Hummel figurines, to name a few. The beloved Willow pattern has been produced in many countries with numerous variations. The Japanese-made Willow, as well as other look-a-like items being collected today, are usually well marked and should pose no problem to knowledgeable collectors.

What about investment value? If you are looking for an investment that will make you or your heirs independently wealthy, perhaps you should stick with your stock broker or keep playing the lotteries. Almost all of the "Made in Japan" items shown in this book are from 50 to more than 70 years old at the present time; they will be considered genuine antiques in a few short years. Only time and demand will determine their value. Collect for the pure fun of the hobby, enjoy and use your treasures. Once you really examine and appreciate the workmanship and artistry of your collection, the true value of these objects will become apparent, if only to you--but after all, who could be a better judge?

There are many "Made in Japan" pieces that are given only limited mention in this book. Willow china, bisque dolls, salt and pepper sets, and Noritake, for example, all have been well covered in other good reference books and I have included a few illustrations herein. This book is intended to acquaint you with the many items not already covered extensively in books currently available.

This book bridges the gap between Japanese imports marked "Nippon" and those marked "Made in Occupied Japan." It offers a brief glimpse of the hundreds of items imported during this twenty-year period and highlights an area of collectibles that has only recently begun attracting the attention of serious collectors.

Section 1.
Background Information
1. History of the markings

Japan opened her ports to Western traders during the 16th century but closed them again in the 17th century and remained in almost total isolation until the 1850s. Then, United States naval officer Matthew C. Perry entered the port of Tokyo and, with full naval strength, persuaded the Japanese government to reopen her ports to trade with the West. At this time, there were no laws requiring that countries mark their exports with the name of their country.

The United States congress passed a law in 1891 requiring that all imports be marked with the name of the country of origin. Japan chose to mark her exports "Nippon," the Japanese word for Japan.

In 1921, the American government ruled that the word "Nippon" was no longer acceptable and required the Japanese to mark their exports "Made in Japan," a practice which continued until the beginning of World War II. From 1941 until 1945, there were no Japanese exports to the United States. During the subsequent years of American occupation of Japan (1945 to 1952), all exports from Japan to the United States were marked "Made in Occupied Japan." Items with this mark are now highly collectible. After the Occupation, Japan marked most of her exports simply "Japan."

Almost all of the items shown in this book bear the backstamp "Made in Japan" which confirms their manufacture to the 1921 through 1941 time frame. There are some exceptions and these are explained in the chapter on Identification Markings and in the captions for some of the newer (and suspected to be newer) pieces of "Made in Japan" ware.

The more familiar you become with the "Made in Japan" collectibles, the easier they will be to spot--almost all have a distinct look and feel you will recognize that sets them apart from items being exported today. The coloring of the earlier "Made in Japan" articles is unique and the detail of the decorated pieces is more elaborate than that shown on more current imports. The workmanship and artistry of many of the pieces is remarkable.

When the Japanese manufactured objects for export to the United States, they catered to American interests and tastes. For instance, a souvenir from Niagara Falls with pictures of the falls will more than likely bear the stamp "Made in Japan" if it was made prior to World War II.

The wide selection of "Made in Japan" objects vary in quality and detail from a crudely made souvenir to a lavishly decorated vase. Many of the objects pictured in this book were intended to be marketed as souvenirs at tourist attractions in the United States. Still others were targeted for the carnival and fair market to be used as prizes. These items were usually rather crudely made, inexpensive, and mass-produced. Other, more artistic pieces they produced were marketed through gift shops, china shops, department stores, and other up-scale distributors. It is in this group that you will find the lovely vases, cookie jars (sometimes called cracker jars), teapots, and pitchers, many with elaborate gold decorations, hand-painted flowers and scenic views. These were more expensive and competed with exports from other countries and with items made in the United States.

2. Hobbies— Just For the Fun of it!

Having a hobby should be encouraged, even among the very young. Hobbies should be considered a necessity for the middle-aged and mandatory for everyone over 50!

Hobbies are the rewards we give ourselves for being good: after we mow the lawn we go fishing or play a round of golf; after marketing and cooking we take a break to do a little quilting or go browsing through an antiques shop. No matter what the vocation, everyone needs a respite from the daily grind-- something that can be pursued for the pure pleasure of doing it-- and is not tied to the daily struggle for survival.

We should even have more than one hobby. Strive for a balance between strenuous and sedentary activities, an indoor and an outdoor hobby, those that can be enjoyed alone and those that can be shared with others.

Collectors of things have the best of all worlds! There is plenty of exercise to be had trudging through flea markets and large antiques malls. Displaying and caring for a collection can afford hours of quiet pleasure. Collectors are not bound by seasons. Collections can be shared through collector clubs and shows, and many friendships are formed through sharing mutual interests.

Collecting the items made in Japan between 1921 and 1941 is a new hobby. While Nippon (1891 to 1921) and Occupied Japan (1945 to 1952) items have many collectors, the 1921-1941 era of "Made in Japan" collectibles has been overlooked.

My collection of "Made in Japan" items actually came about when I needed something different to display above my kitchen cabinets. If you've ever tried to keep a basket collection clean when displayed in this area, you can understand why I was looking for a change. I had a little green cookie jar that had belonged to my mother which was marked "Made in Japan." I started noticing teapots, pitchers, and vases at flea markets and auctions that were also marked "Made in Japan" and I began buying a piece or two here and there until the space above the cabinets was filled. Before long, the microwave and refrigerator top was also covered. Reluctantly, I had to admit to myself that I was hooked on another hobby.

As my interest in this new hobby grew, I looked for a book that covered this period of Japanese exports but could not find one. Several dealers that I spoke to also expressed their frustration at the lack of information available on the china, bisque, and pottery items that Japan exported between the Nippon era and the Occupied Japan era. I remember one particular dealer saying "I sure wish someone would write a guide book on this stuff!" and I thought to myself, "I could do that!" Right or wrong, I gave it my best effort.

While many of the items shown in this book are from my own collection, several pieces were loaned by dealers, friends and relatives to be photographed for this book. Many who shared their "Made in Japan" objects, also shared stories of why a particular memento was precious to them, or from whom it had been a keepsake. Hearing the many beautiful memories was one of the unexpected pleasures experienced while compiling this book.

3. Displaying and Caring for Your Collection

How and where you display your collection will in part be determined by the objects themselves. A collection of tea pots or cookie jars, for example, might add interest to a kitchen or dining room. A collection of vases or figurines might be appropriate in a china or curio cabinet. A display of small figural flower pots can be charming in a window in any room. You might consider a small hanging shelf to display your tiny pincushion holders in your sewing room. The small figural lamps make delightful night-lights in any room. They can be used to accent a plant on a bookcase or any place that needs a little spot of beauty and light.

Those covered containers can be used almost everywhere. On a coffee table, they can hold a deck of cards or potpourri, on a desk they are attractve holders for stamps, paper clips or business cards--all those little objects that need a special place.

I have noticed that the "Made in Japan" objects made prior to World War II have colors that are harmonious. Most pieces can be displayed side-by-side and the result is a lovely blend of hues, not a jarring clash of colors.

You might enjoy a collection of objects, something to add interest to a room, a touch of personality, but find that your space is limited. Consider some of the smaller "Made-in-Japan" items shown throughout this book. There are numerous small figurines, toothpick holders, shoes, pincushion holders, and an almost limitless variety of small planters which take up very little space, yet can be fun to look for and attractive to display.

Almost every flea market offers small hanging shelves or corner "what-nots" that can accommodate several objects. Metal window shelves for display-ing plants can still be found through some seed catalogs and those interesting novelty catalogs. Consider using these to display small planters (with or without plants) and some of the flower frogs you may come across in your treasure hunting.

Most antiques shows and flea markets offer glass covered display cases, those used by antiques and flea market dealers to display merchandise. Consider fitting these cabinets with clear glass or plastic shelves, and hanging them on the wall. These cabinets usually come unfinished, are easily stained or painted, and have the added advantage of keeping those tiny items out of the hands of small children. Another advantage is that they are practically dust-free. These display cases are modestly priced or, if you prefer, you can make them yourself. The cases vary in size; just select the depth and width that most adequately fits the objects you intend to display.

If you choose to display your kitchen items in open areas such as above your kitchen cabinets, you will find that they require more frequent cleaning, something we all abhor! Don't be discouraged, I have found that most items can be washed safely in the dishwasher. Just use one of the more gentle cycles such as "Light Wash." If only dusty, even "Rinse and Hold" will restore the shine and with just a little hand-drying, they will be ready to return to your shelves. For really tough jobs, try using one of those spray cleaners formulated for kitchen clean-up to remove that oily film--it is quick and easy!

Many of the teapots and cookie jars you will find have wicker handles. Often, these wicker handles are either badly damaged or missing altogether. You can find replacement handles at most import shops that carry everything from baskets to pottery to incense burners, etc. These replacement handles are modestly priced. (I have found most priced around 39 cents, sometimes three for a dollar.)

A few words of caution: I wouldn't recommend washing items with heavy gold decoration in the dishwasher--this might damage the gold. Also, certain fragile bisque items might be better hand-washed and dried. Wicker handles should be cleaned very gently--lemon oil works well and keeps the handles from drying and becoming brittle.

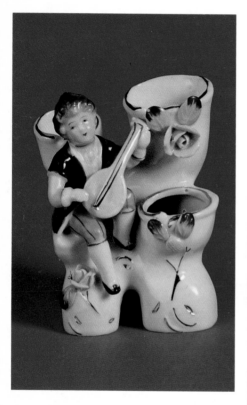

A small china epergne that would look pretty almost anywhere you chose to display it.

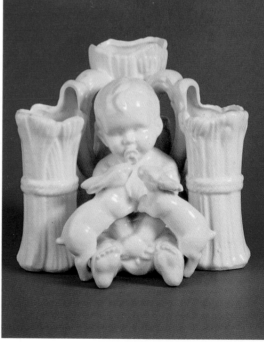

The baby with its pacifier and two little bunnies is just adorable. The piece has a high luster finish and is 6-1/2 inches tall.

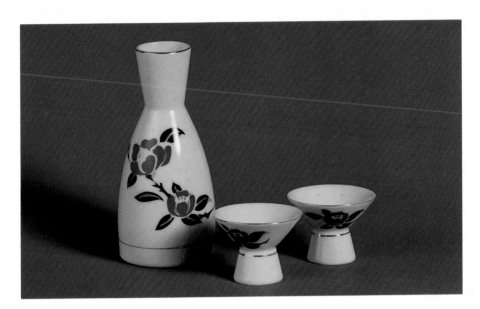

Sake is a Japanese rice liquor. This is
called a sake set. Both the carafe and the
two cups are quite small, which would
suggest that sake is a very potent drink.

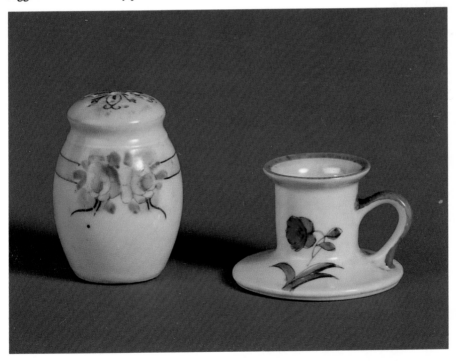

The lovely floral shaker on the left is
probably a sugar shaker. The candleholder
on the right is only 1-1/2 inches tall.

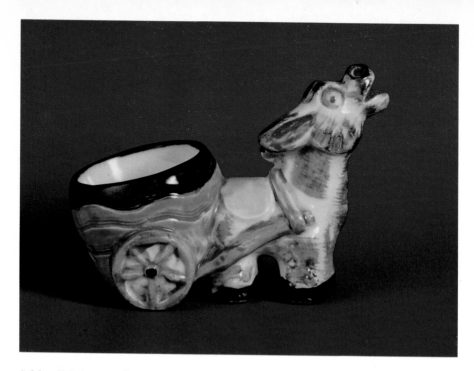

A feisty little burro pulling an egg cup--
what kid could resist a boiled egg served
by this little fellow?

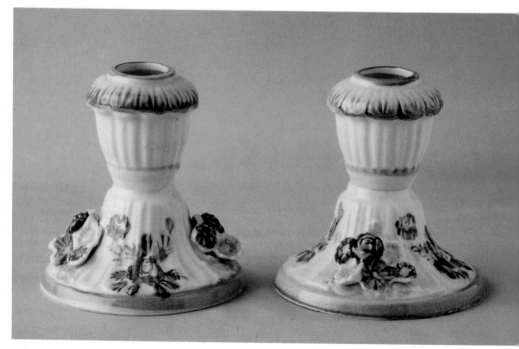

Candleholders are hard to find. These are
4-1/2 inches tall on a 4-inch diameter base.

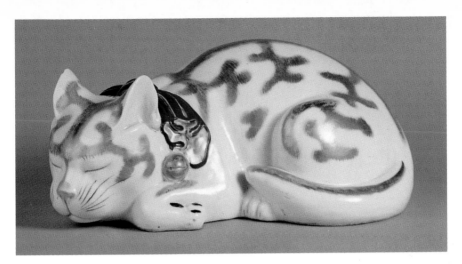

The sleeping Kutani cat. This very heavy cat is solid rather than hollow and has a heavy glaze with gold decorations and is marked "Made in Japan." Kutani porcelain of this type can date from the late nineteenth century. Perhaps it is an old piece exported with the "Made in Japan" mark, or perhaps it was made circa 1921 to 1941.

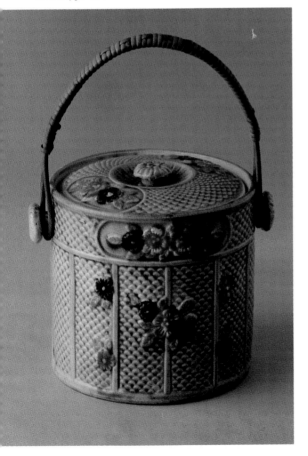

This cookie jar belonged to the author's mother and after her parents died, she asked for the little cookie jar because of the happy memories it brought to mind. One little cookie jar started an entire collection, which became the basis of several magazine articles, which in turn became the inspiration for this book. One wonders where the story of the little cookie jar will end.

1. Ashtrays

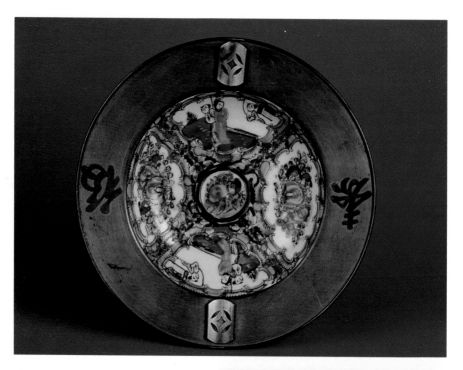

This ashtray with the Rose Medallion-like insert is stamped "Japanese Porcelain Ware decorated in Hong Kong ISCO A." There is a metal frame surrounding the 5-1/2-inch insert and with the metal frame, the ashtray measures 8-1/4 inches. It is quite heavy and certainly not a novelty piece. This may be a more recent import but interesting, nevertheless.

This is only 1-1/2 inches high. The little figure is trying to reach the commode but seems a bit short. The word PLEASE is written on the commode. Was this supposed to be funny?

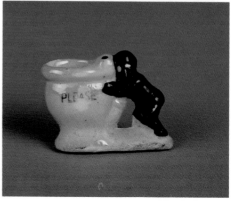

A rather nice ashtray, large enough to be
useful and safer to use than most. Note the
delicate gold decoration.

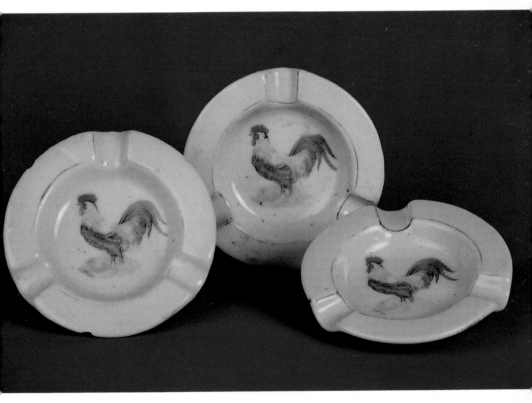

Small individual ashtrays such as these are
not plentiful.

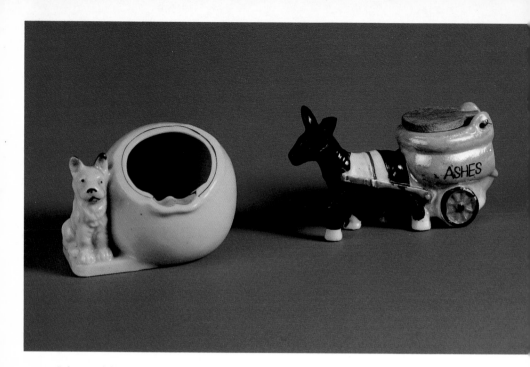

It is surprising how inexpensive novelties such as these have survived so many years.

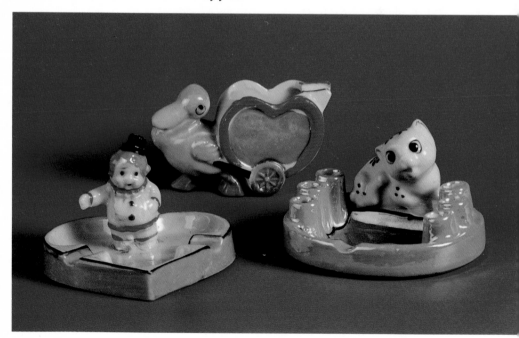

As we move toward becoming a smoke-free society, will ashtrays such as these become artifacts? The duck is only 2 inches tall.

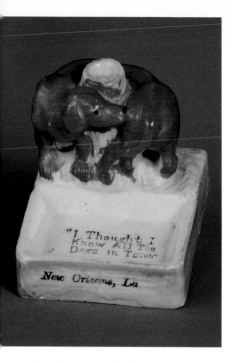

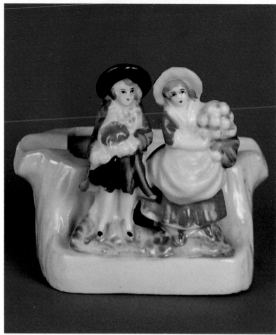

Amusing souvenir ashtray from New Orleans, Louisiana. The paint is very sloppy, the fire hydrant is barely recognizable, yet others of this sort have been found with good painted decoration. Perhaps someone was just having a bad day when this one was made .

This fancy little ashtray would look very nice beside a figural lamp.

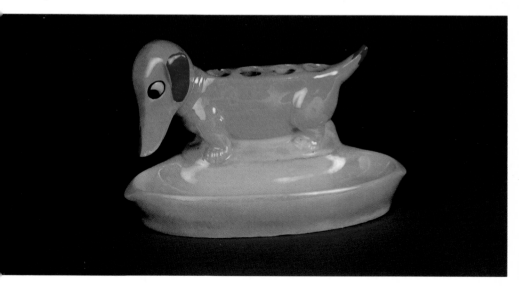

Luster cigarette holder and ashtray. Skinny little dog, see how those cigarettes stunted his growth?

15

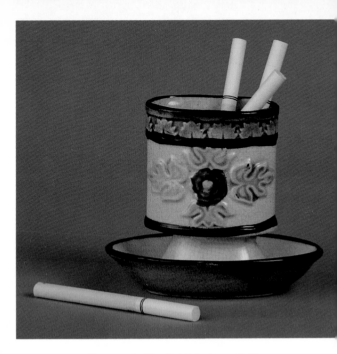

Cigarette holder, 3-1/2 inches tall. The attached underplate looks like an ashtray but does not seem practical.

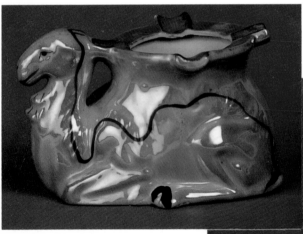

Would you walk a mile for this camel? He is 2-1/2 inches tall and 4-1/2 inches long. The high luster finish is pretty.

You scratch the matches on the soles of the feet ('pon my soul). This may have been intended to be used as a match holder with the burned matches disposed of through the mouth or an ashtray as well.

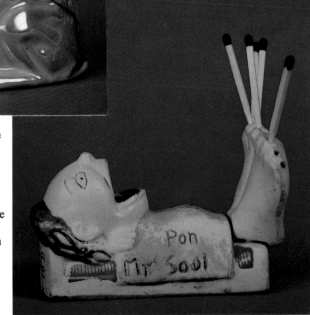

These two 3-inch ashtrays are both marked
"Made in Japan" but the one on the left is a
pre-War item, the one on the right is a
recent import. Comparing the two should
help you in identifying old and new items.

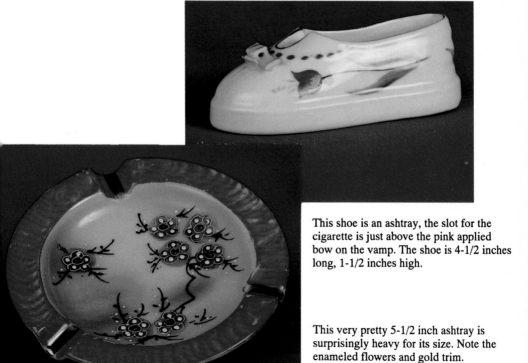

This shoe is an ashtray, the slot for the
cigarette is just above the pink applied
bow on the vamp. The shoe is 4-1/2 inches
long, 1-1/2 inches high.

This very pretty 5-1/2 inch ashtray is
surprisingly heavy for its size. Note the
enameled flowers and gold trim.

2. Bookends

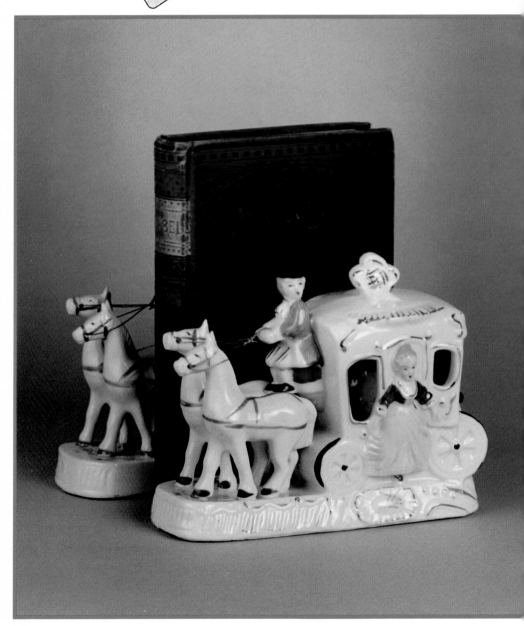

The prettiest bookends in my collection.
These are quite large, 5-1/4 inches tall on a
7-inch base.

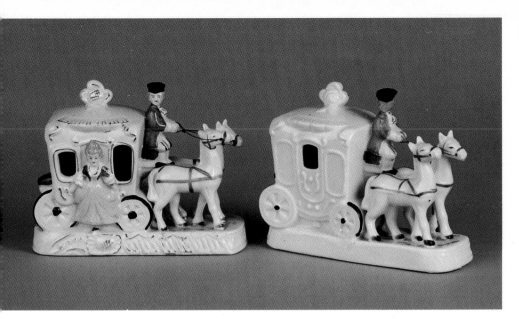

Another view of the bookends--it appears that two different painters worked on this set, the base beneath the horses has lots of green paint on one bookend, very little on the other. The hubs on the stagecoach wheels are larger on one coach than the other, and it must have been the end of the day because the painter didn't even finish outlining the wheels with black paint.

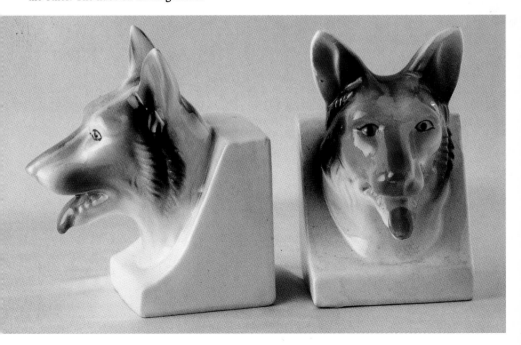

Finding a pair of bookends is a red-letter day, since breakage is common. Most bookends have holes in the bottom which can be filled with sand to provide weight. The hole is then covered with tape and felt is applied to the base. These bookends are 5-1/4 inches tall.

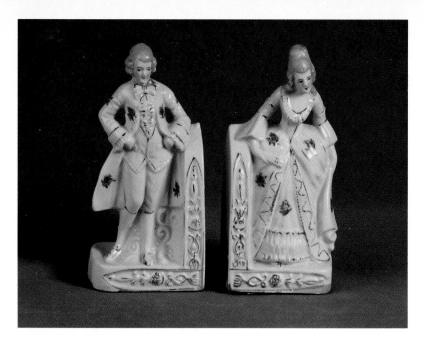

A pair of large figural bookends, 7-1/2 inches tall, which are quite heavy when weighted with sand.

Smaller bookends, very delicate and very pretty. They look nice used as figurines without the books.

3. *Childrens Tea Sets*

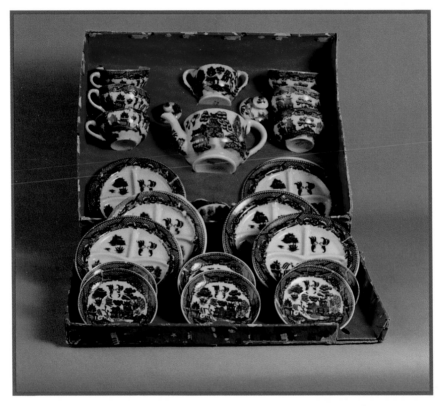

Willow pattern children's tea sets are highly prized. This set is unique for several reasons: first, it is in the original box; second, it has grill (divided) plates; and third, it has the covered tureen and the platter.

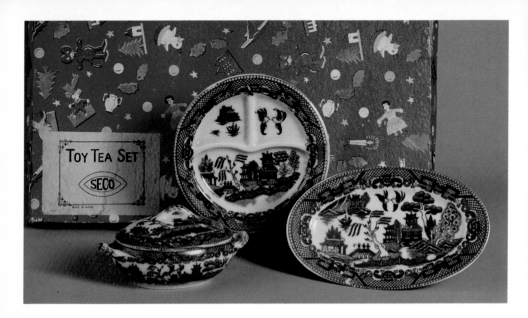

The grill plates, covered tureen and the
platter for closer examination.

Detail of the box for the Willow tea set. It
is quite unusual to find original boxes this
well preserved.

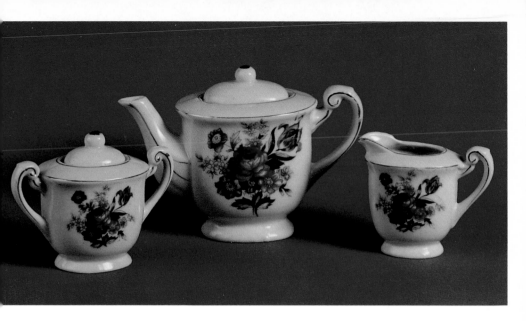

This would have been a more expensive set, because of the fine painting on the flowers and general workmanship. This set has service for 6 and is in perfect condition.

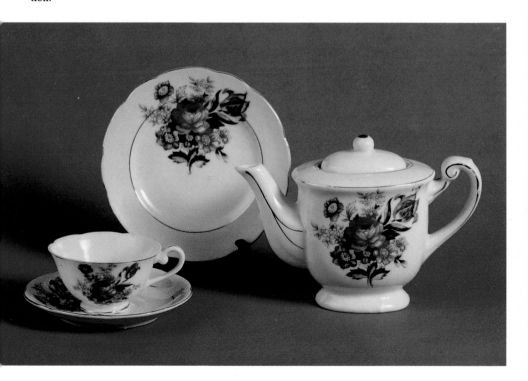

The plate and tea pot with a cup and saucer of the set.

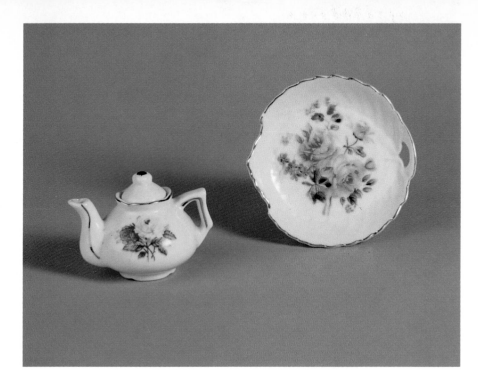

A miniature cake or sandwich server and
miniature teapot. The floral designs on
both pieces are very well done.

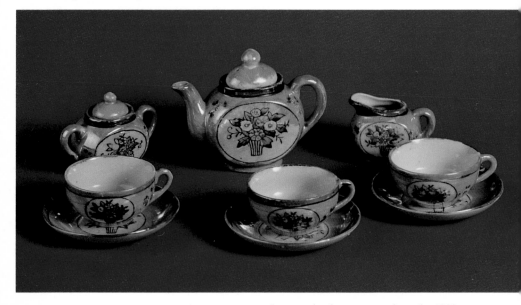

Inexpensive luster tea set from the 1930s.
Tea sets such as this usually cost around
25 cents back then, expect to pay around
40 dollars or more today. Buying back
your childhood can be expensive!

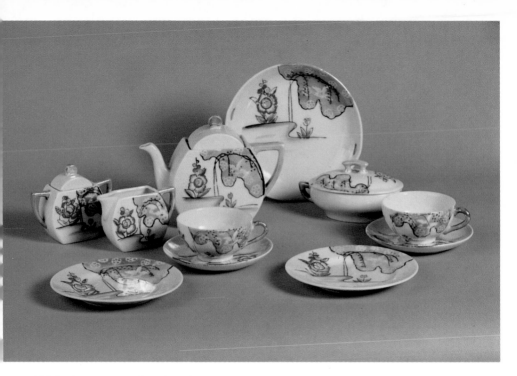

Children's tea sets that have been kept without breakage or loss for 50 to 70 years and more are rather rare. This set has service for six and the pieces are large enough for a real tea party. The serving plate and covered tureen are rare among children's tea sets. The tea pot is 3-1/2 inches tall, the server is 6-1/2 inches wide, the cup is 1-1/2 inches tall, and 3 inches wide.

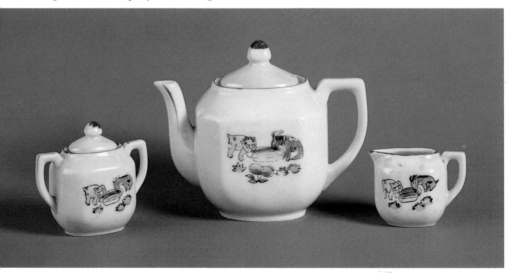

Children's tea sets are favorites of collector's everywhere. The less expensive children's tea sets usually consisted of a tea pot, creamer, sugar, 3 cups and saucers, and 3 plates.

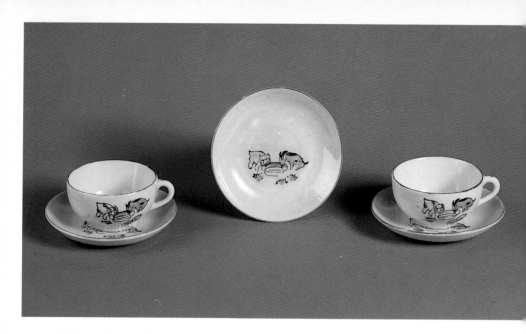

A plate and cups and saucers to the set.

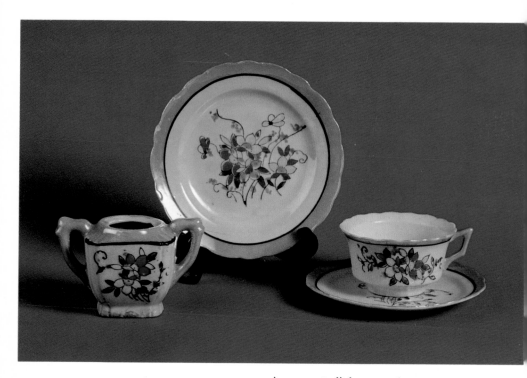

A very pretty little pattern, but not many
pieces of the original set remain. Still, it is
part of someone's childhood memories and
each piece is precious to its owner.

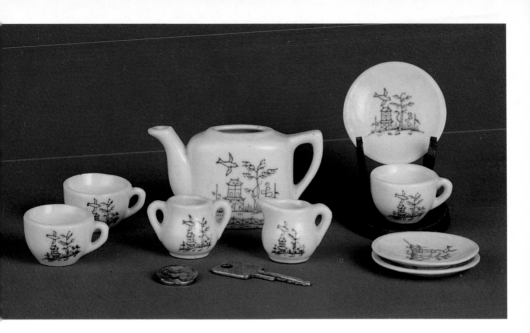

A very small tea set in a variation of the
Willow pattern. The key and the nickel
give a good size comparison.

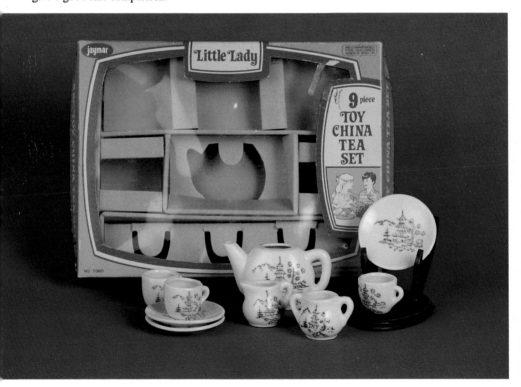

Another Willow pattern variation, this
small tea set has the original box.

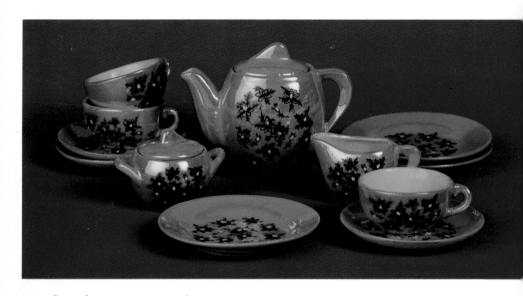

Pretty forget-me-not pattern luster tea set.
Teapot is 3-1/2 inches tall, plates 3-3/4
inches in diameter.

4. Condiment Sets and Mustard Pots

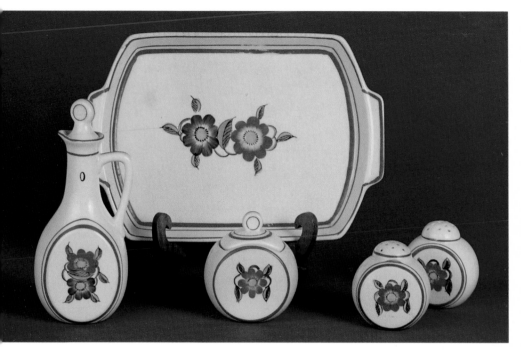

A very nice condiment set. The tray is 9-1/2 x 6-1/2 inches, the cruet is 6-3/4 inches tall, and the salt and pepper shakers are 2-1/2 inches tall. Unfortunately, the vinegar cruet was missing, but who knows, with a little effort a replacement may be found.

Very pretty little luster condiment set with matching tray.

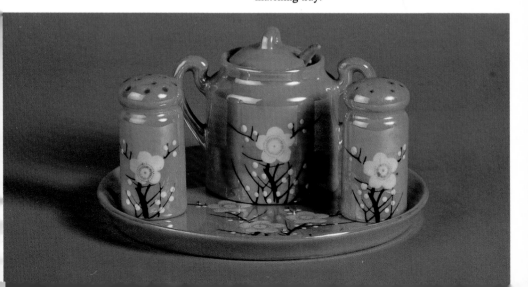

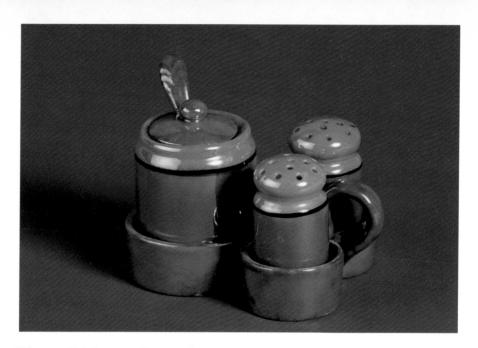

This pretty little luster condiment set is a treasured memento of "Grandma Hattie" and only the heart can assess a value.

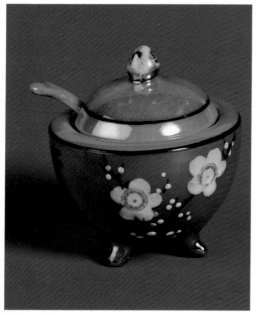

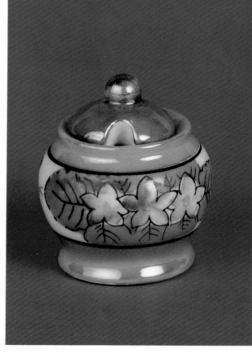

This little mustard pot was evidently not quite so treasured, it was offered at a garage sale for a quarter! The "now" generation uses plastic squeeze bottles and they are great for convenience, but isn't this prettier?

A very small mustard jar, probably part of a condiment set.

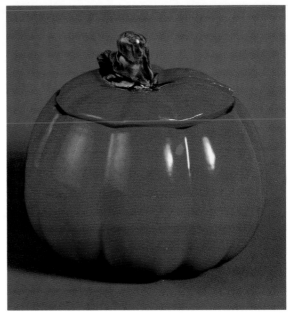

This honey pot is 2-1/2 wide, sits on a 2-3/4-inch base, and is 3-1/2 inches tall. A little white spoon fits in the opening on the roof. The honey pot is marked "Noritake Made in Japan."

This mustard jar is marked "Made in Japan". Compare with the genuine royal Bayreuth mustard jar pictured below, left.

This covered bowl has 6 slots cut in the lid. It would make a nice holder for pot pourri or fragrance beads. The bowl is 3 1/2 inches tall and 4 1/2 inches in diameter.

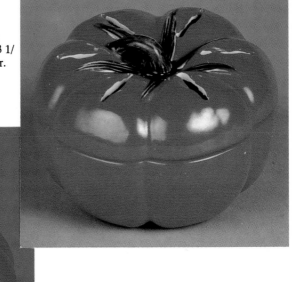

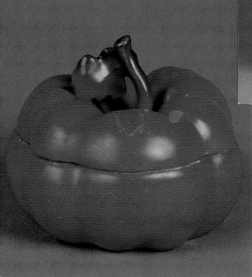

This mustard jar is stamped " Royal Beyreuth" and is shown here for comparison. American potters also made their own versions of tomato–shaped items.

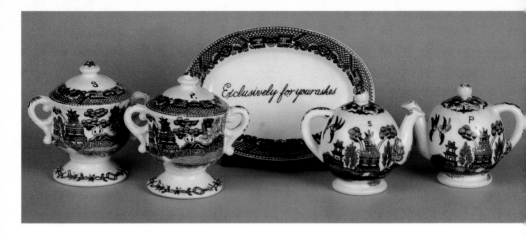

The tip tray or ashtray in the background is 5 inches by 4 inches. The salt and pepper set on the left is 3-1/2 inches tall and the set on the right is 3 inches.

This large shaker is called a muffineer. Fill it with sugar and maybe a bit of cinnamon, shake a little of the mix on hot buttered toast--yum! The muffineer is 5-3/4 inches tall.

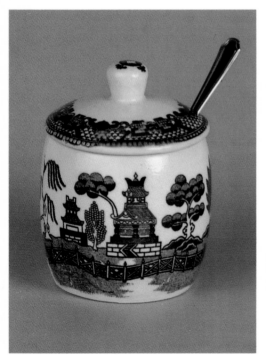

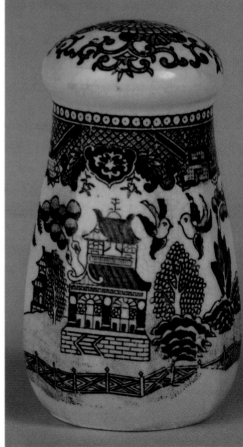

Very nice mustard jar with slotted lid, 4-1/2 inches overall. Mustard jars can be found with or without an underplate attached.

5. Cookie Jars

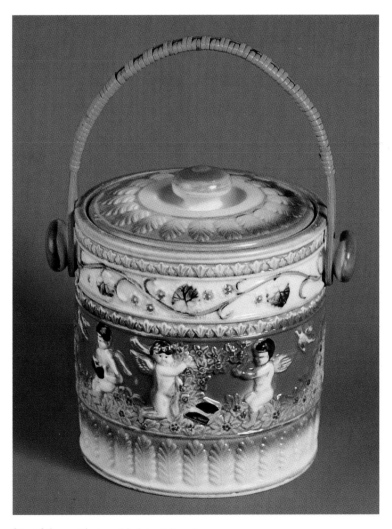

One of the prettiest cookie jars. It is quite
large, measuring 6-1/2 inches in height and
6 inches in diameter.

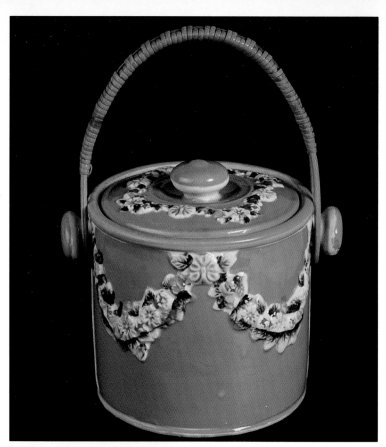

A beautiful cookie jar. The workmanship is excellent and the colors are very pleasing. There is a sugar and creamer elsewhere in this book that match this piece.

This large cookie jar is quite colorful. The detail on the lid and back of the jar are unusual.

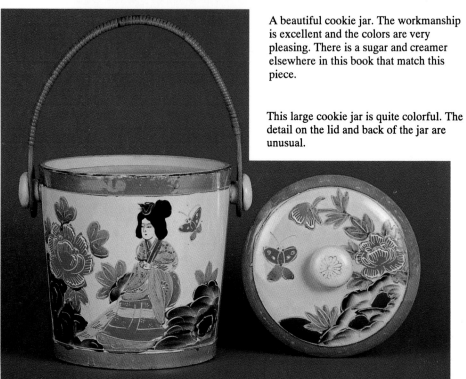

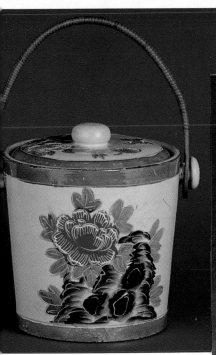

Back of cookie jar.

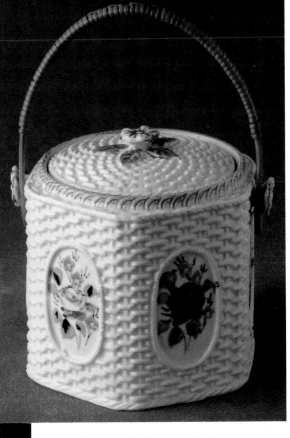

Another large cookie jar measuring 7 inches tall and 6-1/2 inches in diameter. The floral medallions are attractive and the raised floral knob and leaves make a very pretty lid.

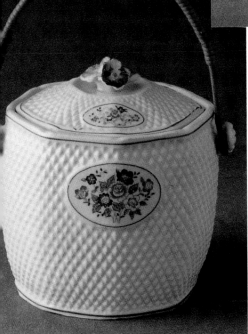

A large, family-size cookie jar. The painted floral design is very nicely done. The pebble-like surface is rather difficult to clean if you display items such as these in your kitchen.

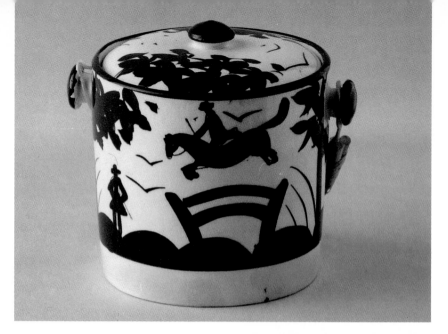

This handsome cookie jar with the hunting scene in black-on-white is quite a change from the usual floral decorated pieces in my collection. The jar is 6 inches tall and 5-1/4 inches in diameter.

A 5-inch cookie jar? This one is so small it would be more suitable for animal crackers or oyster crackers.

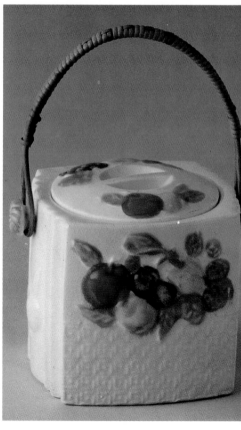

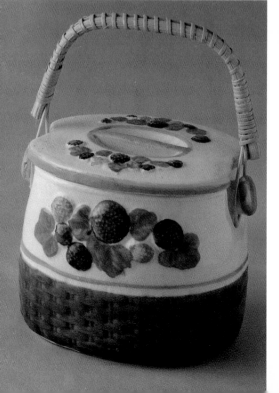

Cookie jars come in all sizes, this is one of the smaller ones, only 5-1/2 x 5 inches.

Old "Made in Japan" cookie jars usually have wicker handles. This jar is large, (7 inches tall) and has a pineapple background, which is a departure from the usual basketweave or plain backgrounds.

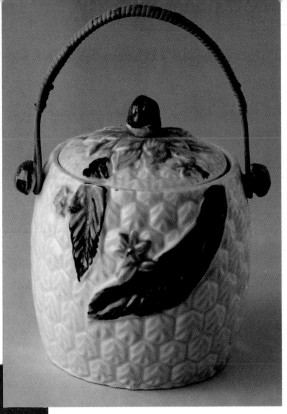

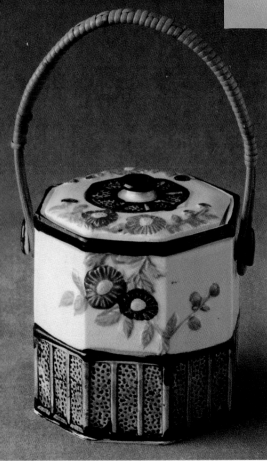

Whoever designed these little cookie jars certainly didn't have small boys in mind. My two sons could have emptied this one in a single stop.

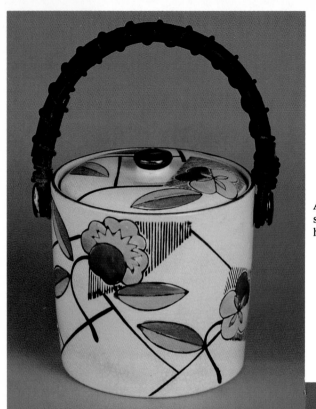

Another pretty cookie jar. The handle seems to be original, but is almost too heavy for the dainty look of the jar.

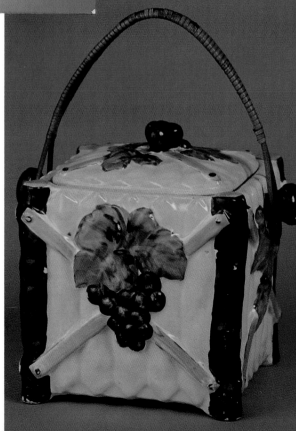

A large cookie jar, 8 inches tall and 6-1/2 inches square. Kitchen colors during the mid to late 1930s may seem gaudy today, but probably seemed cheery during the dark days of the Depression.

One of the prettiest covered boxes, the intended use of this particular piece is unknown, it could have been a part of a dresser set or wash set. There has been a lot of gold trim on the base but much of it has been worn away over the years. This is the type of piece that should be washed very gently to preserve the gold as much as possible. This box measures 5-1/4 inches square and is 4-1/2 inches tall.

Another very pretty covered box that matches the other box. Although the shape is different and the size is smaller (5 x 3-3/8 inches and 3-1/2 inches tall) the design and colors are the same.

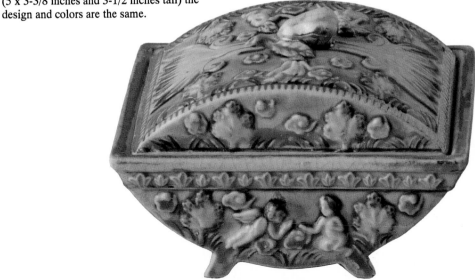

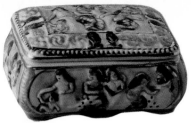

A cigarette box and two matching ashtrays. The ashtrays can be stored inside the box which measures 5 x 3-1/2 inches and is 3 inches tall. The ashtrays are 3-1/4 x 2-1/2 inches.

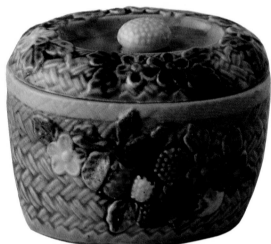

This covered box is a good storage place for paper clips, stamps, or any number of small objects that need to be kept handy but look like clutter. Size is 3-1/2 x 4 inches.

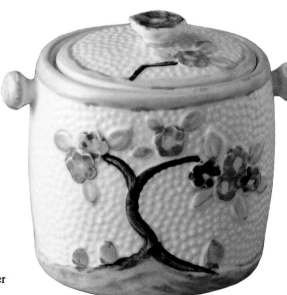

This covered box looks like a miniature cookie jar but needs a replacement wicker handle small enough to fit.

A handy 4 x 5 inch covered box, stamped Made in Japan, ELITE. A bit large for a cigarette box, this would be a nice holder for a deck of cards. The box is attractive, the little cherubs being sweet images.

2-3/4-inch Satsuma incense burner.

This little box looks like china at first glance, but it is made of papier-mache or some sort of pressed wood. The contents had been untouched since the owner died some 20 years ago and everything was stored very neatly. People do use these items--this was probably kept on a dresser and was a pretty way to keep minor items organized and out of sight.

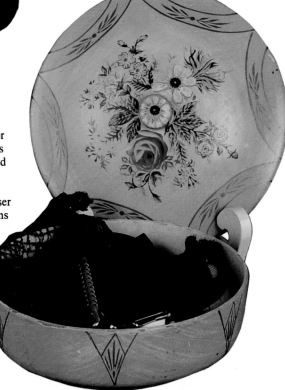

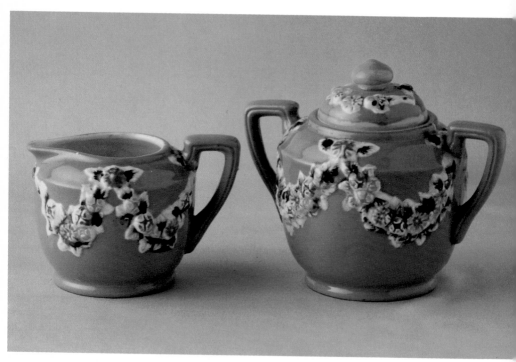

One of the prettiest patterns I have found. The blue is lovely and the quality of material is quite good. The creamer is 3-7/8 inches tall, the sugar is 5 inches tall. There are other pieces to be found in this pattern, just keep looking.

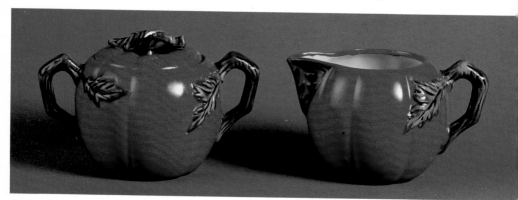

A creamer and sugar in the tomato shape. The creamer is 3 inches tall and marked "Made in Japan," the sugar is 3-1/2 inches tall and unmarked. I have seen numerous pieces in this pattern with at least three different marks.

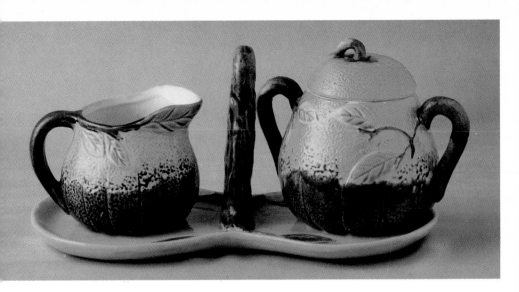

Two oranges are certainly more appetizing on the breakfast table. This is a pretty little set, and there may be other pieces to match, such as teapots or cookie jars, just keep looking!

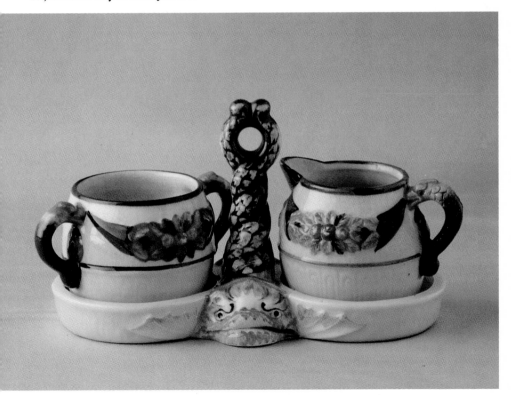

The sugar and creamer on this tray are pretty, but the handle for the tray is not something to stare at while sipping morning coffee. Front and back are identical with snakes with their tails wrapped together. My fisherman son insists they are two fish--what do you think?

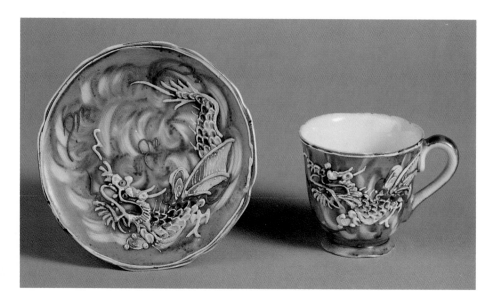

This especially pretty set is called
"Dragonware." You may find larger pieces
and pieces with different colored back-
ground. The body of the dragon is rough
and feels like scales.

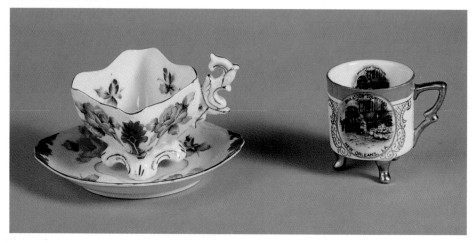

A nice little floral cup and saucer and a
footed cup that is a souvenir of New
Orleans. Note the decorations on the
insides of both cups.

This is a handsome set. The saucer
measures 5 inches across, the cup is 1-7/8
inches tall.

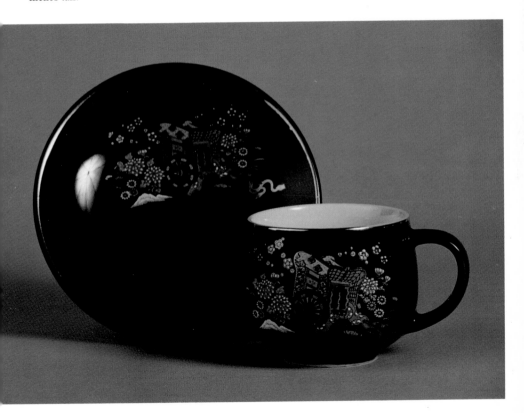

One of the larger cup and saucer sets with
an Oriental cart design. This is very
attractive.

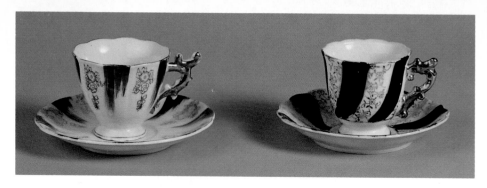

Two miniature cup and saucer sets. The saucers are about 3-1/2 inches across, the cups are about 1-1/2 inches tall. Note all the gold decoration on the handles--you won't find this detail at today's gold prices!

Two very small cups and saucers. The leaf-shaped saucer on the left is unusual.

This is the smallest cup and saucer in this group. The wedding band in the foreground gives an idea of scale. There are even smaller sets, this just seems small enough to me.

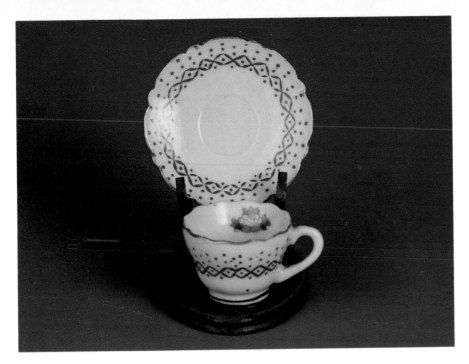

A pretty miniature cup and saucer.

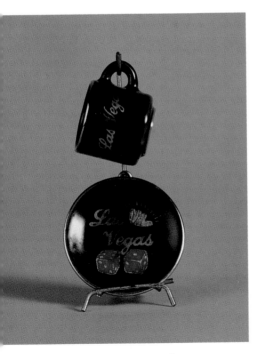

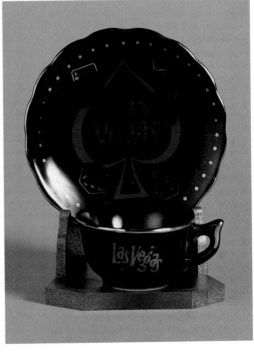

This souvenir cup and saucer set is really small--the saucer is only 2 inches across and the cup is 1-1/4 inches tall.

The saucer is 3-1/4 inches across, the cup is 1 inch tall.

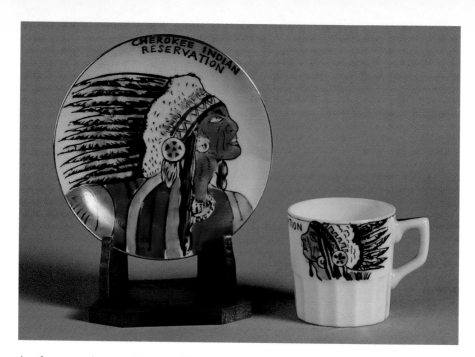

Another souvenir cup and saucer--this
Cherokee Indian Reservation set has a
4-inch saucer and the cup is 2 inches tall.

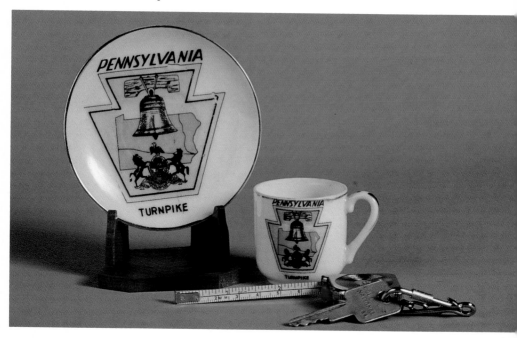

Like this souvenir set for the Pennsylvania
Turnpike, many of the items exported from
Japan were sold through souvenir shops
and tourist attractions throughout the
United States. Judging by the amount of
these items still around, sales must have
been very, very good.

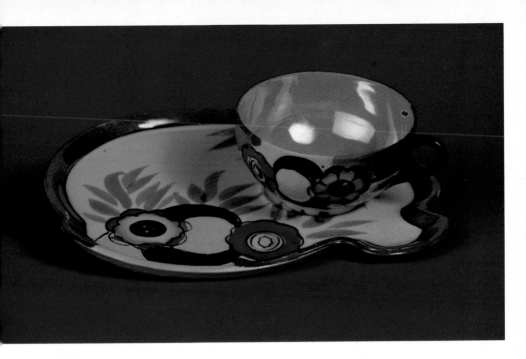

A pretty snack set, the tray is 8 inches
long. Note the beautiful luster finish on the
inside of the cup.

A very pretty snack set. The tray is 9
inches long, the cup is 1-2/4 inches tall and
very thin and fragile.

MADE IN JAPAN

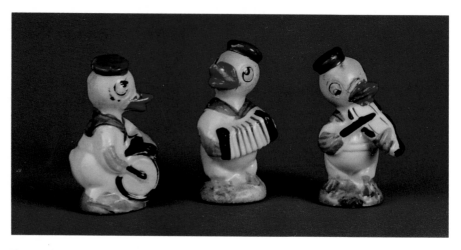

Eat your hearts out, Disneyanna collectors! These little Donald Duck figures are 2-1/2 inches tall and just as cute as can be. There is also a 2-1/2 inch tall "Sneezy" figure from a Snow White and Seven Dwarfs set.

A handy little scotty dog paperweight for a desk, if you like to have your collectibles serve some useful purpose. It is nice to look at, whatever the use.

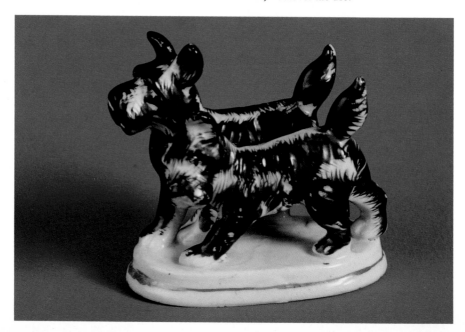

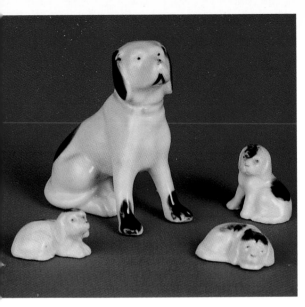

Cute little family group, the mama dog is
2-3/4 inches high, the puppies are 1/2 inch
to an inch in height.

This winsome little fellow is 4-1/2 inches
high. Not many figures of animals were
not attached to a planter, ashtray, or some
other object.

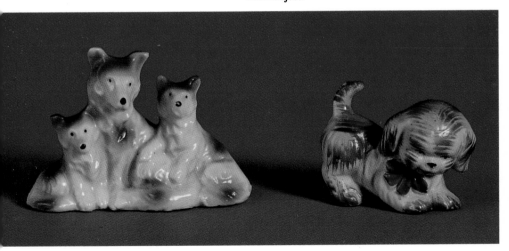

More novelty items--man's best friend.
The puppy on the right is a lovable looking
little fellow, isn't he?

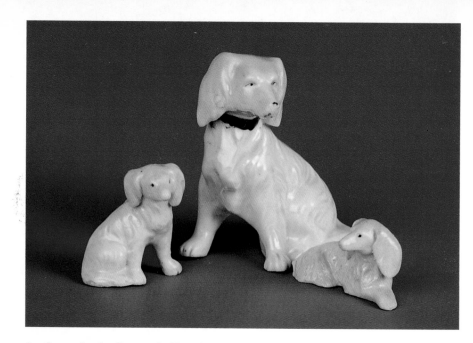

Another canine family portrait. These have
a lovely luster finish.

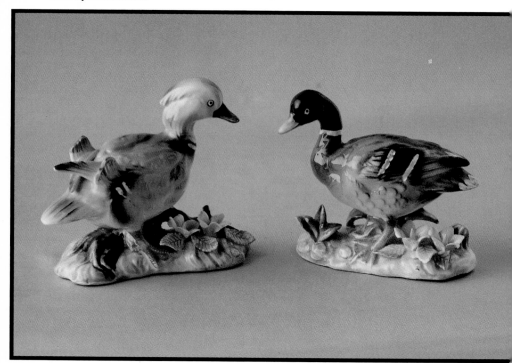

These two little ducks are examples of
recent imports. They are very attractive
and marked simply "Japan." Even though
one collects primarily older "Made in
Japan" articles, every now and then you
just can not resist one of the newer pieces,
and why should you? The ducks are
approximately 4-1/2 inches tall.

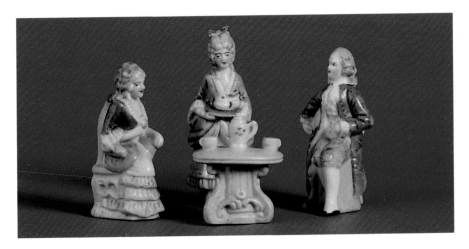

This tiny set is a real cutie! The table is 2-1/4 inches high, the seated figures are 3 inches high, and the standing figure is 3-1/2 inches high. The little tea set is molded to the table.

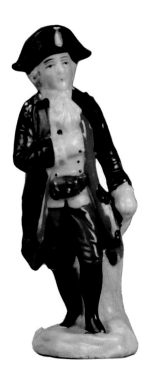

Cute little figure sitting on a ladybug. This novelty piece is 3-1/2 inches tall.

Who does he think he is, Napolean?

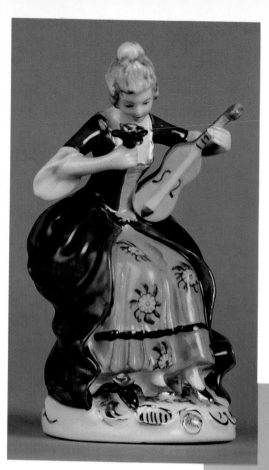

Just a pretty 6-inch lady with golden slippers.

Two large figurines, these are 8-3/4 inches tall. These pieces have an excellent glaze and the painting is very good, both front and back.

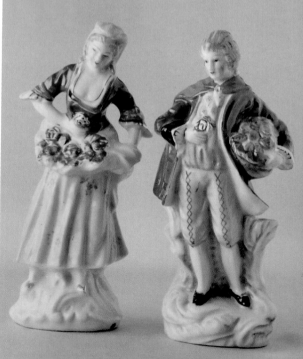

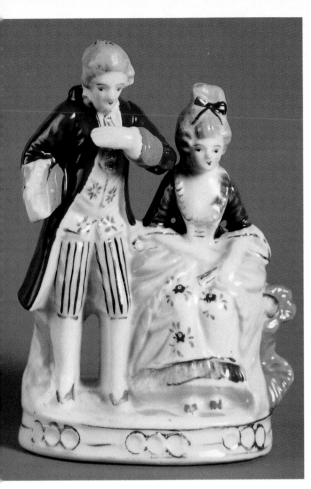

A very pretty group that is 6 inches tall.

This figure is 5-1/2 inches high.

These 5-1/2 inch harlequin figures are colorful.

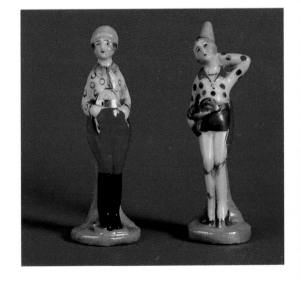

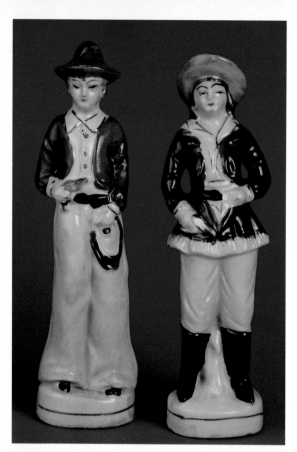

Most of the figurines are of people dressed in colonial or Victorian clothing, so this cowboy and cowgirl pair is unusual.

The couple on the left have very little painted detail, but the boy on the right is more colorful. We never did decide what he is holding in his arms--a pig in a poke, perhaps?

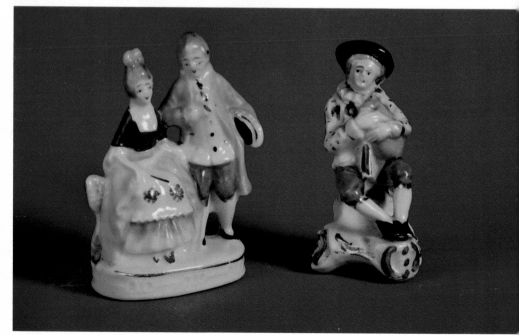

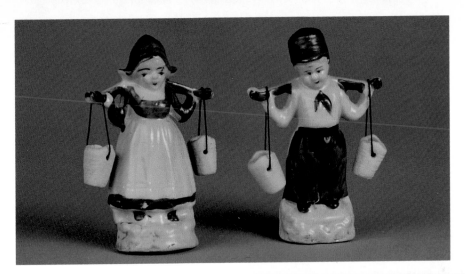

It isn't often that you will find these little Dutch figures with both buckets. They are charming in any size.

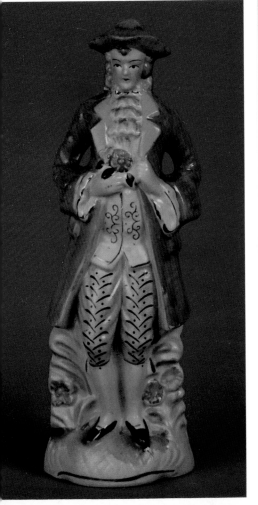

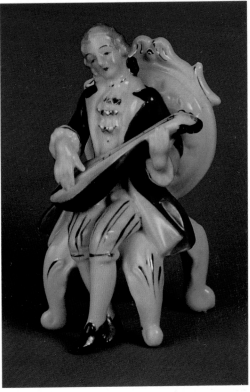

There are a lot of legs in this picture, aren't there? The seated mandolin player is 5 inches tall.

Male figure, 10-1/2 inches tall. He looks like he is dressed up to go courting (or to a costume ball.) You wouldn't be safe going anywhere dressed like this today.

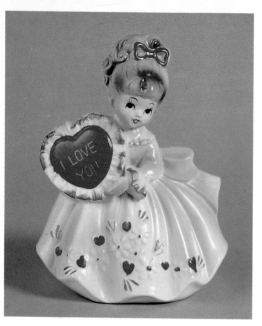

This lovely little Valentine lady stands 7-1/2 inches tall and may be a more recent import, it has a paper label stamped "Made in Japan."

Little cherub.

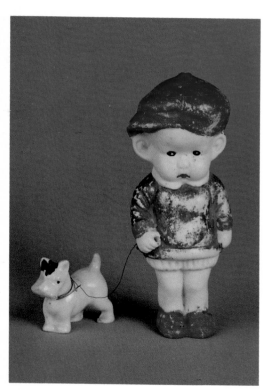

This little guy and his dog have been together a long time. Note the hole in the little boy's hand that the leash for the dog is threaded through. This figure is reported to be of Jackie Coogan, a child star during the 1920's. In 1924 he was paid $22,000 per week and his parents gave him an allowance of $6.25 per week. When he was 21 years old, he had less than $15,000 left from the millions he had made. Mismanagement of his earnings by either parents or agents led to the passage of a law protecting incomes of child actors and is known as the Coogan Act. Jackie Coogan was a glider pilot during World War II.

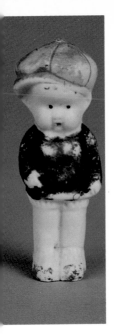

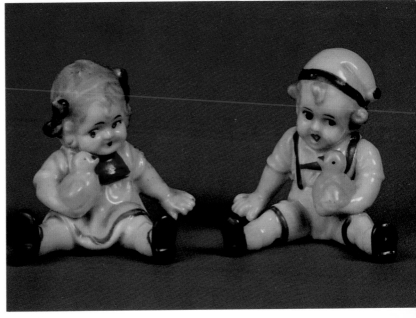

A smaller version of the same little guy. This one does not have the hole for a leash, but that is not a problem, he doesn't have a dog, either.

A precious little pair, the girl is 2-1/4 inches and the boy is 2-3/4 inches tall.

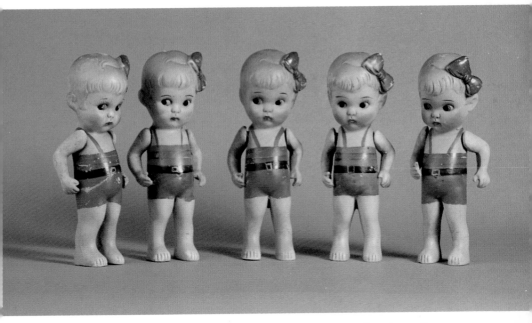

How about these little beauties! The owner of the dolls called them her "Dionne Quintuplets" when she was a little girl. It is obvious that they were given lots of

Tender Loving Care--all are in excellent condition except that a little paint got loved off. The dolls are 6-1/2 inches tall.

11. *Flower Arrangers*

MADE IN JAPAN

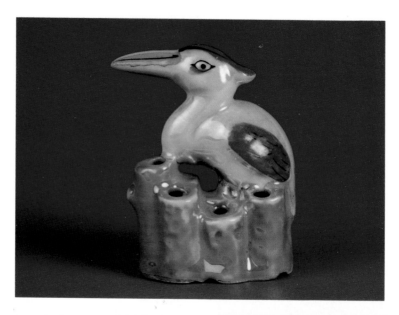

Flower frogs (or flower arrangers) have not been plentiful and when found are relatively expensive. The one pictured above is 3-1/4 inches tall.

The bluebird is 2-1/2 inches tall, the ducks are 5 inches tall.

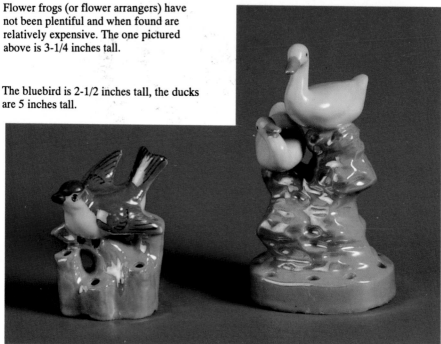

12. Lamps

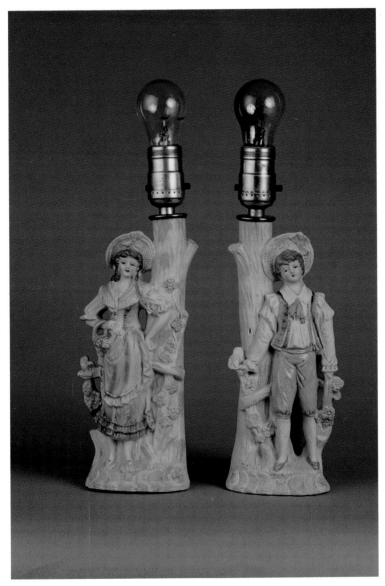

The workmanship and quality of these
bisque lamps is exceptional!

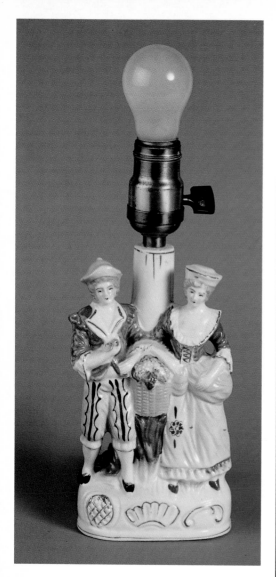

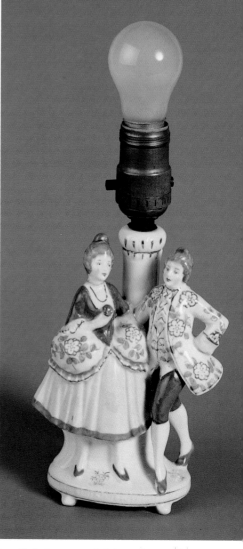

Small lamps such as you will see in the following photographs are not too hard to find. Most lamps I have found are one-of-a-kind, but it is possible to find matched pairs. This lamp is 7-1/4 inches tall to the base of the fixture.

These little lamps can brighten the top of a bookshelf or highlight a small display of collectibles. They make attractive night lights. This lamp is 6-1/2 inches in height.

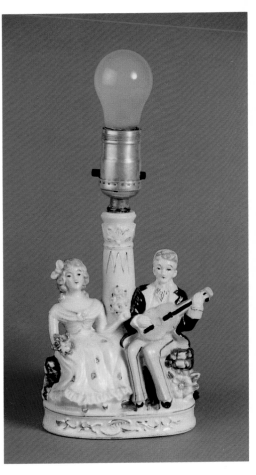

Most of the figural lamps have a lady and gentleman dressed in colonial attire, and the figures are usually standing. This couple is a bit different as both are seated. Figural lamps are used by antiques dealers and shop owners to add light to their displays. Quite often they are for sale, but as they are in use, you may overlook them. That's your hint for the day, happy hunting!

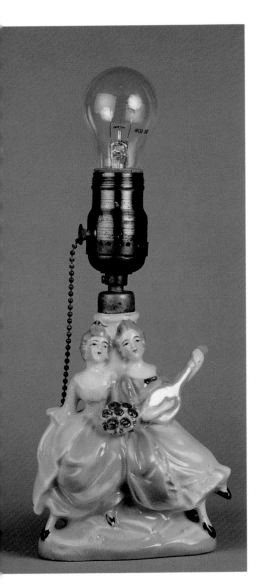

A nice figural lamp. Always check the wiring on these older lamps before you use them; if the wiring appears to be original, replace it immediately.

13. *Mugs and Tobys*

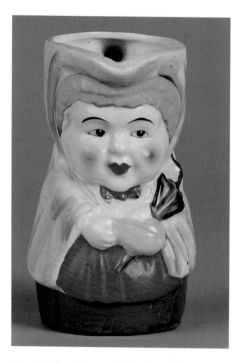

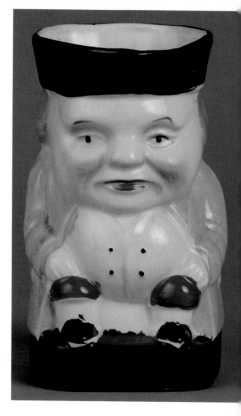

A pretty figural mug--she is about 4 inches tall and quite colorful.

This shady-looking character is a pitcher and not a mug, but he looked so out-of-place among all those pretty pitchers that he was moved here with the other characters where he will be much happier! This piece is about 4-1/2 inches tall.

Toby-like mug, about 5 inches tall.

Let's call him Tiny Toby, he is only 2 inches tall.

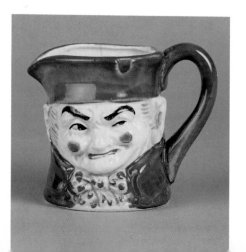

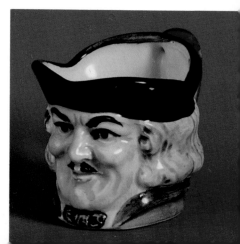

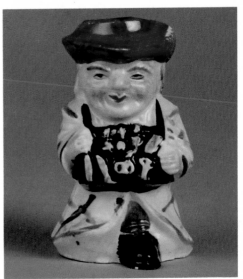

This cute little accordion player is only 3 inches tall.

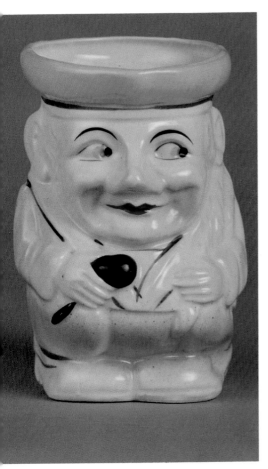

A rather sly looking Toby, but what he is holding in his hand--a pipe or a blackjack?

We would not want to meet him in a dark alley, would we? The mug is 5-1/2 inches tall.

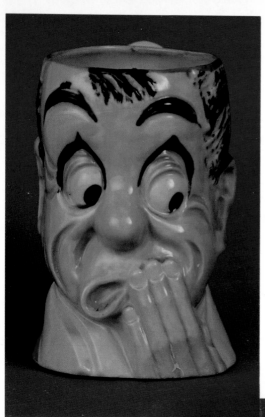

With a mug like this, no wonder he is called a character mug! If you are wondering why he looks so apprehensive, see the next photo.

You would be apprehensive too, if that funny looking varmint was climbing up the back of your neck! It looks a little bit like a dog, has a tiny tail, but no legs.

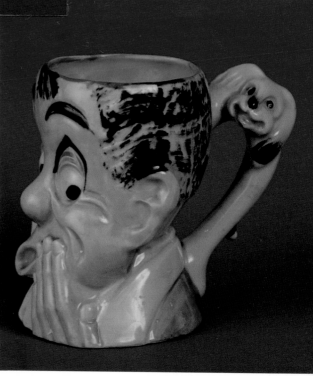

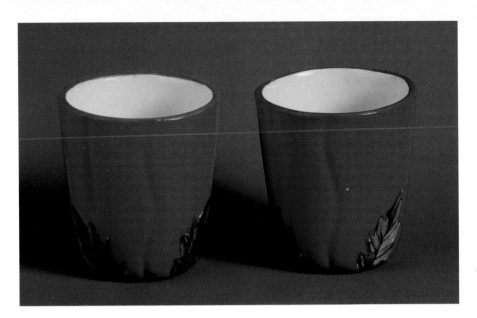

These mugs hold 10 ounces and were sold both with the tomato-shaped teapots shown in this book and as a set of six with the tomato-shaped pitcher. One size fits all, apparently.

This lovely set is in excellent condition.

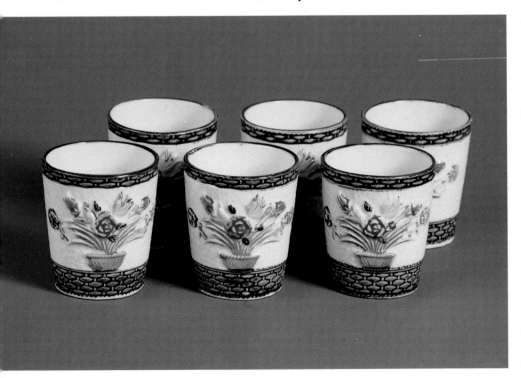

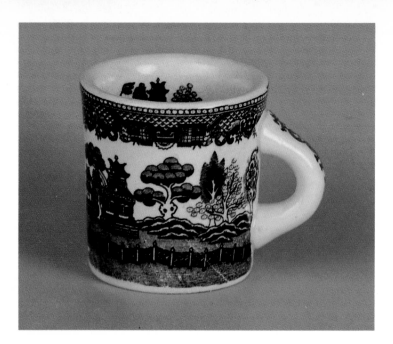

This is called a "Farmer's Mug." Good
pattern coverage, note the inside motif.
The mug is 3-1/2 inches tall.

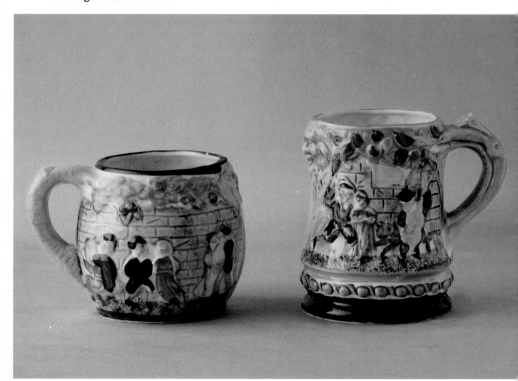

Two mugs.

14. *Pincushion Holders*

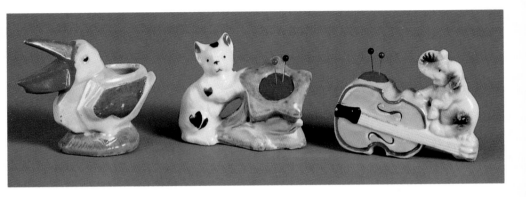

If you like miniatures, you could really get hooked on collecting pincushion holders. Some are quite tiny, some are very elaborately painted, and some are crudely made and barely painted at all.

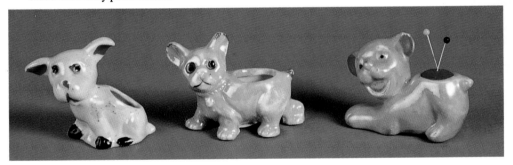

Most of these little pincushion holders are 2-1/2 inches tall or smaller. Note the little luster pup on the right, you will see him in the next picture where he is trimmed in green.

More pincushion holders--the variety seems endless!

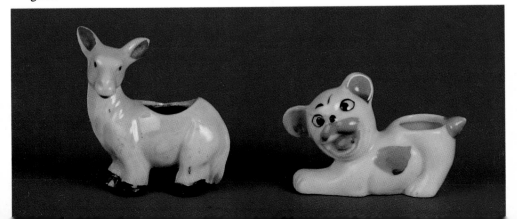

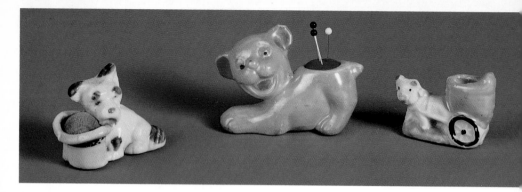

Dogs seem to be popular pincushion carriers, that pup in the center is quite a ham, he managed to get himself photographed again!

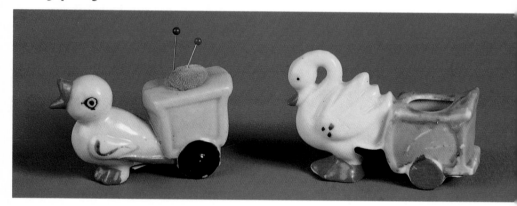

A chick and a swan pulling carts that hold the pincushions, looks like everyone works on Old McDonald's farm!

Many of the pincushion holders you will find have had the pincushion material removed or will be in a damaged condition. If you wish to replace the tiny pincushions, try to use bits of older velvet or satin so that the replacement will be less noticeable.

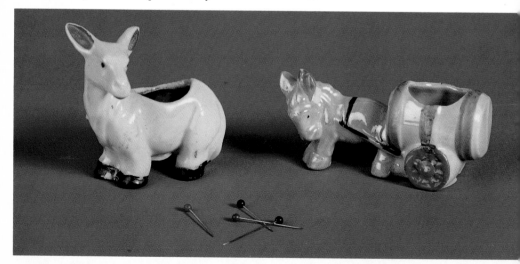

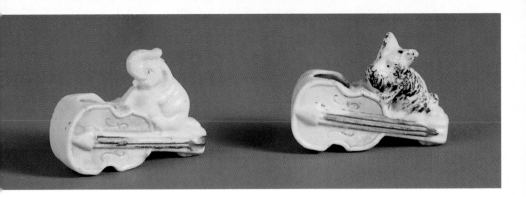

You have to train your eyes to look for these tiny pincushion holders, they are easily overlooked. The examples shown here have very little paint left on them, whether they ever did have very much or whether some little child played with them until the paint was worn away is anyone's guess.

Pelican and child. The top of the pelican's back is open and could be used as a vase or perhaps to hold a pin cushion. This pretty little what-not is about 3 inches tall.

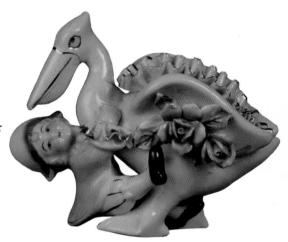

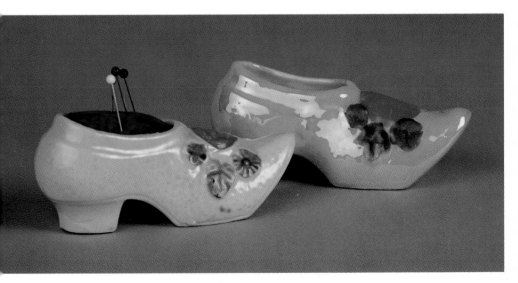

Shoe pincushion holders--both have luster finish but in different colors.

15. Pitchers

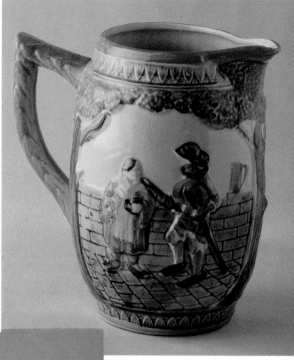

This large pitcher is 8-1/2 inches tall and holds 96 ounces. The pitcher has two different scenes, this side might be showing two friends meeting on the street and one asks the other to dinner.

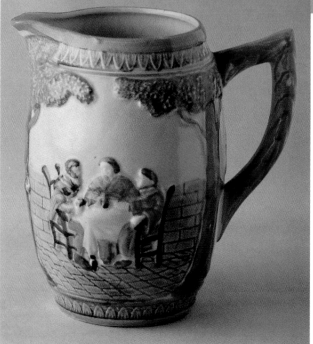

This is the back side of the pitcher. It would appear that the friend accepted the invitation and is now enjoying the hospitality of his friend and wife.

An ordinary pitcher but very
pretty, it is only 4-1/2 inches
tall.

Short and squat describes this pitcher
which is 4-1/2 inches tall and 5-1/2 inches
in diameter. Basketweave backgrounds are
quite common on pitchers and cookie jars
made in Japan.

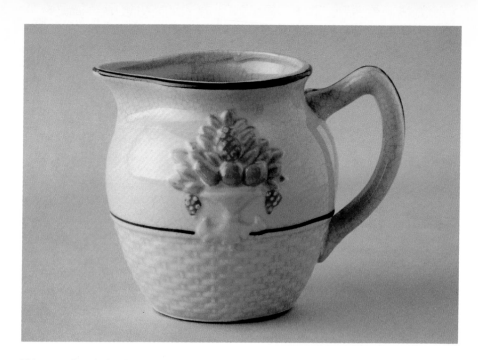

This attractive pitcher has a smooth top
portion and a basketweave base. The
pitcher is 4 inches tall.

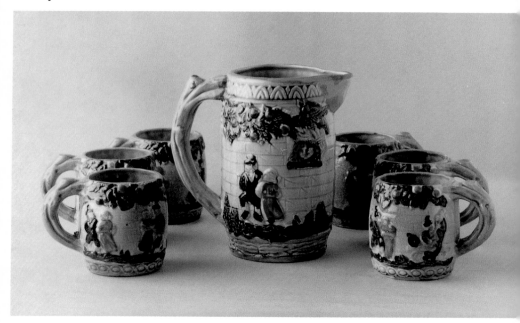

Wouldn't this be a nice set to use when
serving cider and doughnuts? The cups
hold a generous 10 ounces. The pitcher is
7 inches tall and the cups are 3-1/2 inches
tall.

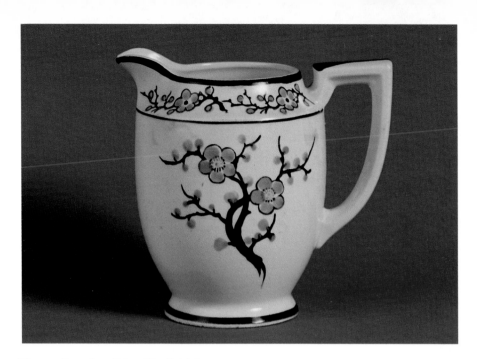

Nice medium-size pitcher. The finish is
excellent, no crazing and very smooth.

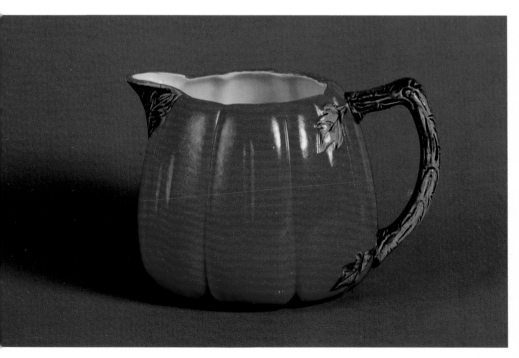

A very nice pitcher in the tomato design.
The pitcher is 5 inches tall and holds 40
ounces.

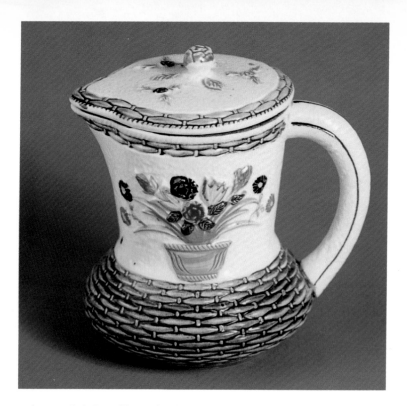

An unusual covered pitcher of large size, it measures 7 inches in height and holds 40 ounces.

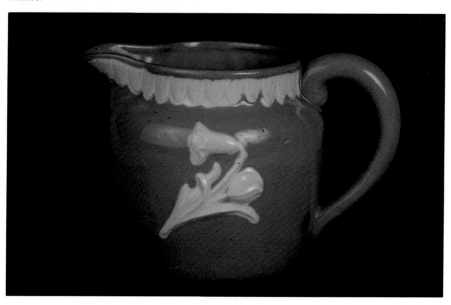

A few years ago, this lovely blue ware, a copy of Wedgwood jasperware, seemed to be everywhere but in the last couple of years they have been scarce. Maybe other people liked it, too, and took it off the market!

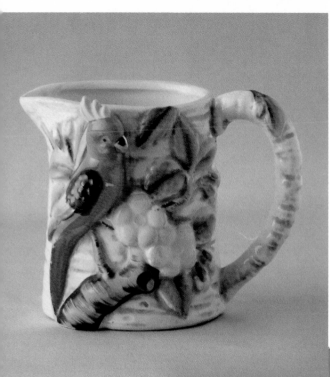

A lovely 5-inch pitcher. Birds are popular subjects on items made in Japan during the period 1921 through 1941. There does not seem to be any rule that says the bird has to be identifiable. This is a red bird--but three or four "topknots" and a blue wing certainly does not depict our beloved cardinal. Perhaps it is a rare tropical species.

This 5-1/2 inch tall majolica-like pitcher is attractive as shown here, but the colors clash, particularly the orange on the handle. This pitcher is also found with a lid and it looks much nicer.

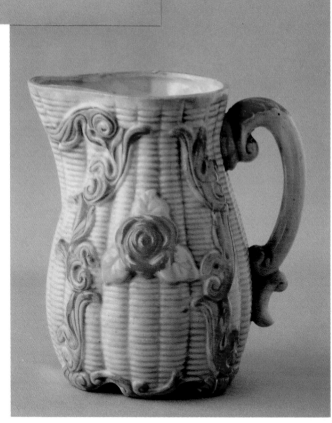

Just an ordinary little pitcher, but it has a quaint charm all its own.

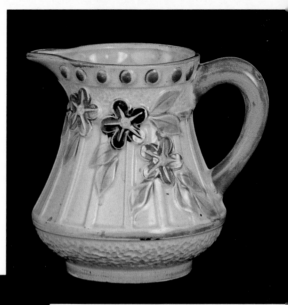

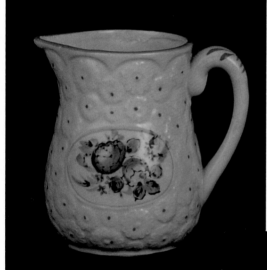

A small cream pitcher, there are probably a matching sugar bowl and other pieces to be found with a little searching.

A small pitcher with a lid just automatically gets labeled as a syrup pitcher, right or wrong.

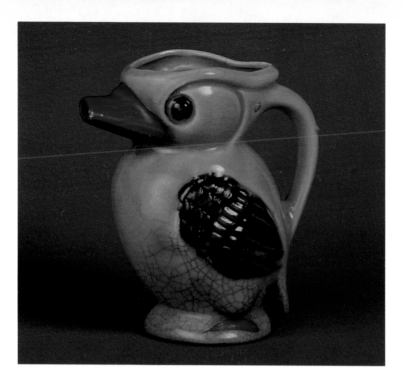

The toucan pitcher is 4-1/2 inches tall and can be found in various colors. These little pitchers either were very poorly made or were used a great deal. Few can be found without scratched paint, crazing, chips, or cracks.

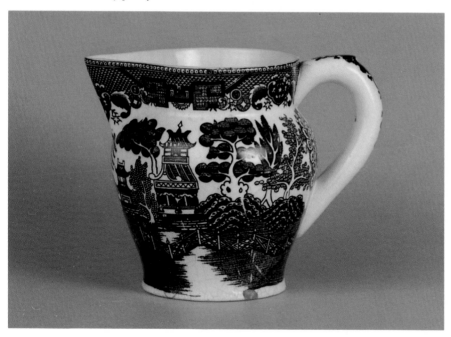

A graceful 5-1/2 inch earthenware pitcher. Even the handle of the pitcher is decorated.

16. Planters

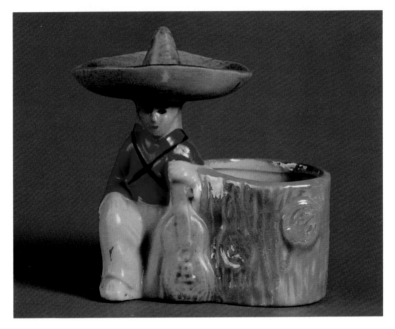

Mexican themes include burros, cactus, and characters.

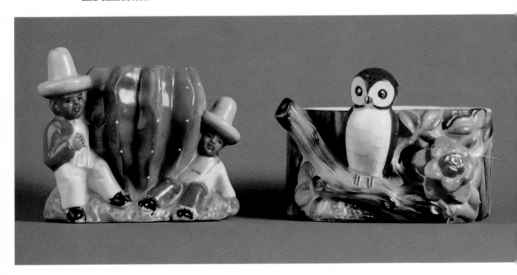

Two very nice planters, these are about 3-1/2 inches tall and quite colorful.

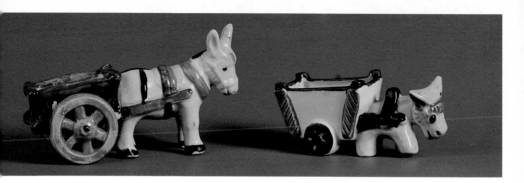

Two perky little burros head out to work in
the morning. These figures are 4-1/2
inches tall and about 6-1/2 inches long.

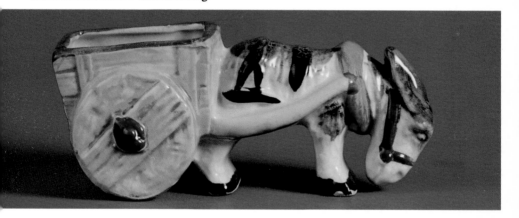

And one little burro just can't seem to get
started! This burro and cart is only 2-1/2
inches tall and is 6 inches long.

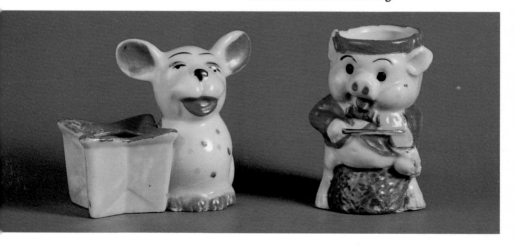

A pair of happy characters such as these
would appeal to a child--or the child in all
of us!

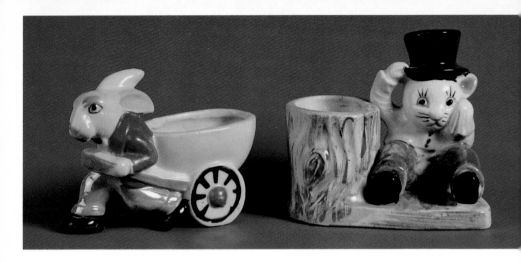

Did the rabbit steal the bear's cart?

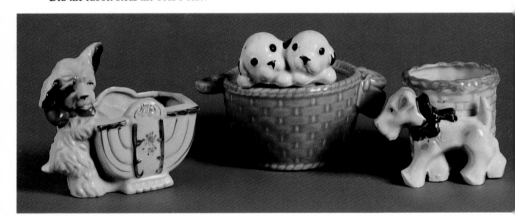

Figures of dogs decorate every sort of
novelty imaginable. How about that basket
of puppies?

A nice large planter but the workmanship
is poor. This was probably a carnival prize
or very inexpensive souvenir. Planter is
7-1/8 inches long, 3-1/2 inches tall.

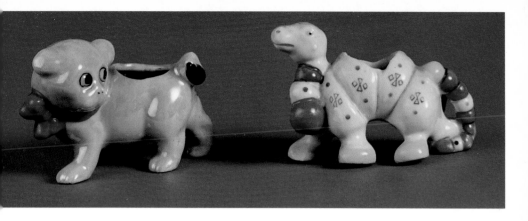

Did you ever get that feeling that something or someone is following you? This pup is just realizing his worst nightmare!

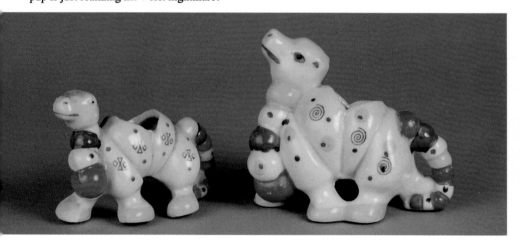

Yes, that little critter on the left is in the last picture but when the larger version was found he was included again for comparison. There is quite a bit of workmanship on these, but why would anyone make anything so ugly twice? Ugly or not, they are almost cute, aren't they?

A pair of planters that appear to be made from the same mold but they are painted differently and each has a different backstamp.

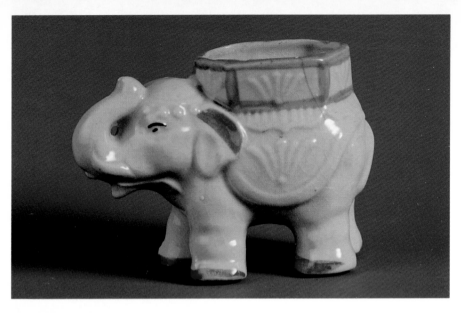

This chubby little elephant shows rough
use but he is charming, crack and all.

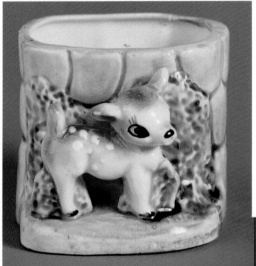

This is a cute little planter which is large
enough to be used as a pencil holder, too.

We are getting the horse laugh on this 4 x
5-1/3 inch planter.

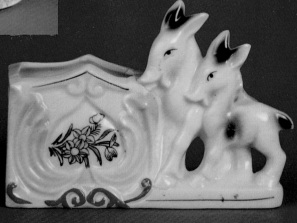

If ducks love water, why is this one hiding under the umbrella?

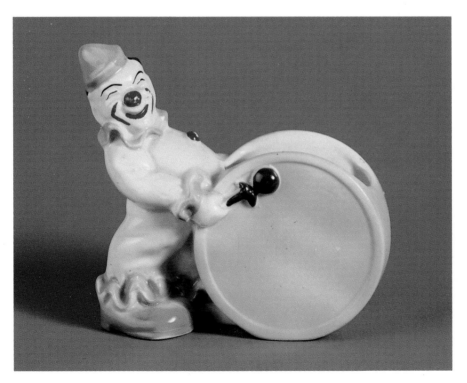

This clown probably was meant to hold a plant in his drum, but his owner fills the drum with gaily colored paper napkins, adding a cheery note to the breakfast bar.

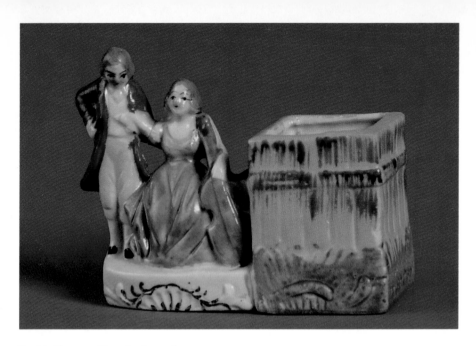

Double figures with a planter are less commonly found. The painting on this charming colonial couple is not perfect but the colors make this an attractive little planter, nevertheless.

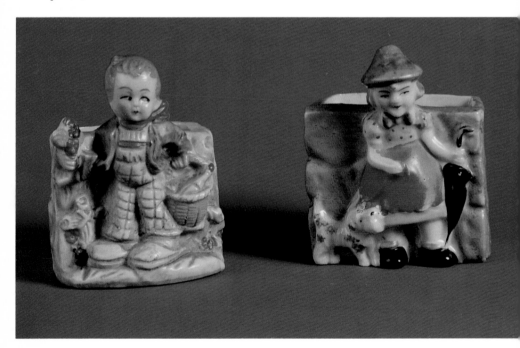

It looks like picnic time for the children, and of course a puppy tags along.

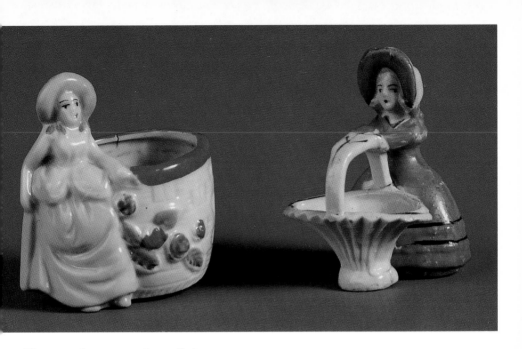

These two planters are quite small, the lady with the basket is only 3-1/2 inches tall.

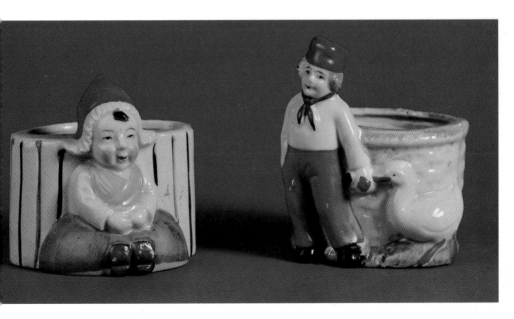

A pair of Dutch children. The bright colors add a cheerful touch.

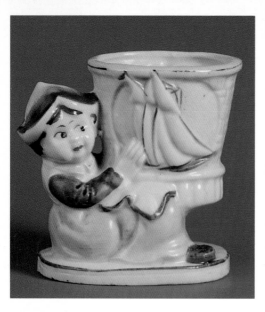

Small planters such as these are plentiful, inexpensive, and fun to collect. They would make an excellent collectible for a child. Most of these planters are approximately 4 inches tall.

The smallest basket in this group, it measures 2 inches tall and 2-1/2 inches long.

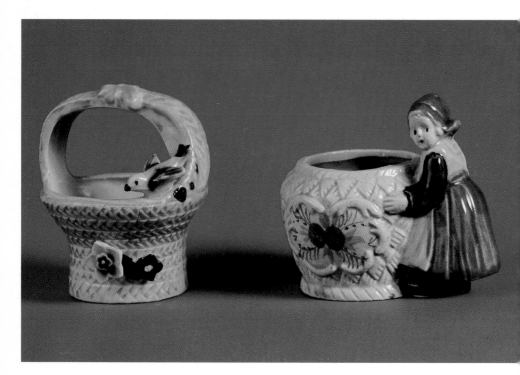

A couple of planters that are easy to find with a variety of painted decoration.

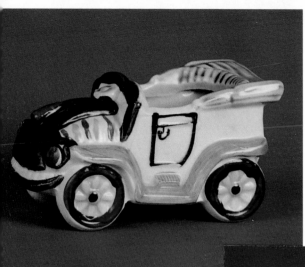

This colorful convertible planter is 5-1/2 inches long by 2-1/2 inches high. It is a nice companion piece for the train engine planter.

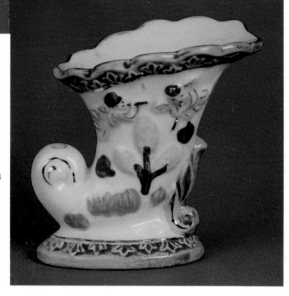

A pretty 3-1/2-inch cornucopia planter with cherubs. More than likely, this was an inexpensive piece when it was made.

The engine planter shown here is 3 inches high and 4-1/2 inches long. There may be more pieces to the train.

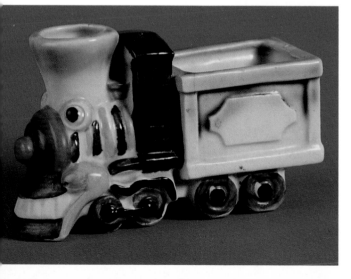

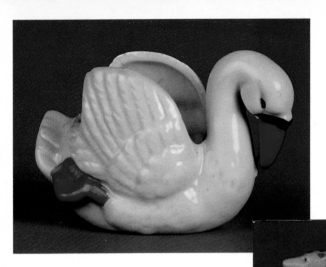

We shall call this "D.J's swan." (Young D.J. is the photographer's son and assistant and he let us photograph his little planter--wasn't that nice of him?)

Giraffe and stump, 5-3/4 inches tall. This stump is beginning to look awfully familiar!

This swan planter is quite plain, but graceful. It is 4-1/4 inches tall.

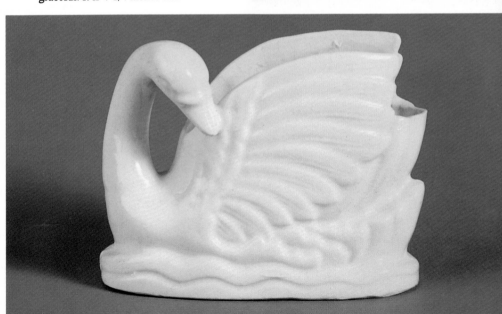

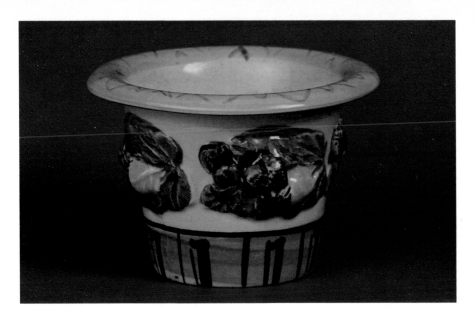

A very nicely finished 3-3/4 inch flower pot. The smooth wide rim is ideal to support the leaves of an african violet plant.

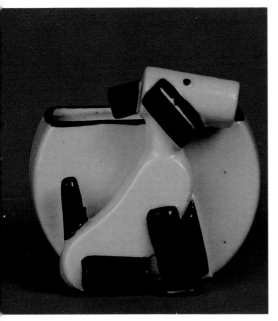

A high-heel pink luster shoe with a winged cherub on the vamp is a bit unusual. The shoe is 4-1/2 inches long and 2-1/2 inches high. There is quite a bit of gold trim, this was not an inexpensive trinket to produce.

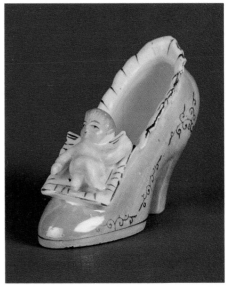

Definitely an Art Deco dog. Black and white, 3-3/4 inches tall.

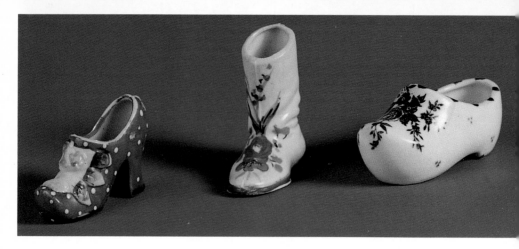

A lot of people collect small glass and ceramic shoes and they do make an interesting collection. The shoe on the left is 2 inches high, the center one is 3 inches, and the one on the right is 2 inches.

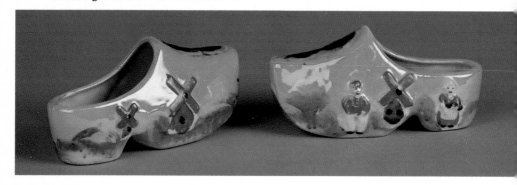

A pair of Dutch shoe planters. The design is different on each side. The shoes are 5 inches long and 2-1/2 inches high.

A little bootie planter to add to the shoe collection. This one has two holes in the cuff.

Oriental motif six-sided dish, quite small, it only measures 3 inches from corner to corner. This would be pretty on a desk to hold paper clips.

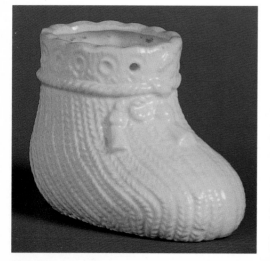

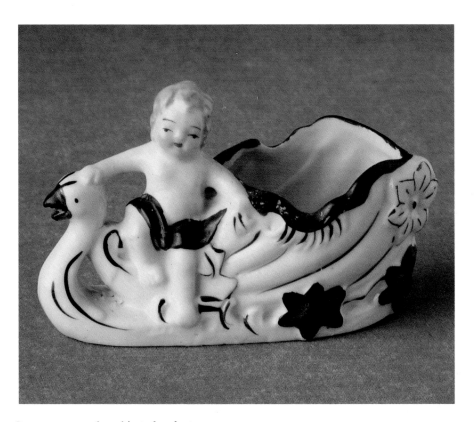

Swans were popular subjects for planters.
This one is unusual because it is in black
and white. The vivid coloring of the
cherub's head seems out of place. This
swan is 3-1/2 inches tall and 6 inches long.

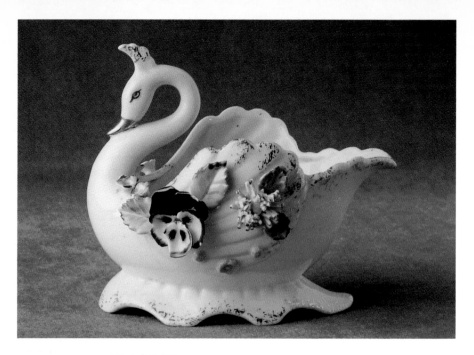

A graceful swan so delicately made yet it
was found in good condition.

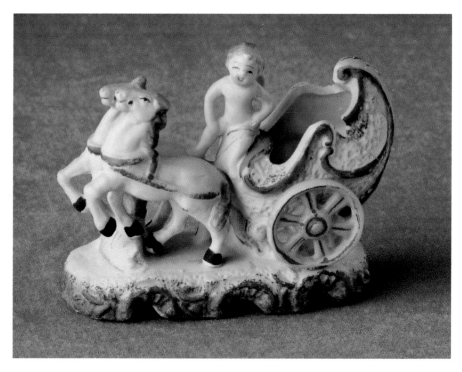

A little bisque planter, too pretty to fill
with dirt, is enjoyed as it is.

A pretty little planter--again, almost too pretty to fill with dirt. The planter measures 4-1/4 inches in height and is 7 inches long.

Those swans are as pretty going as they are coming.

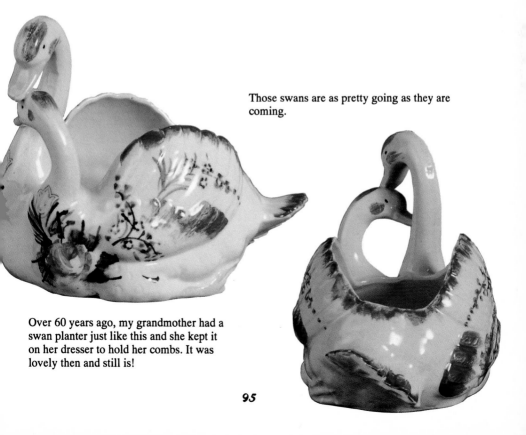

Over 60 years ago, my grandmother had a swan planter just like this and she kept it on her dresser to hold her combs. It was lovely then and still is!

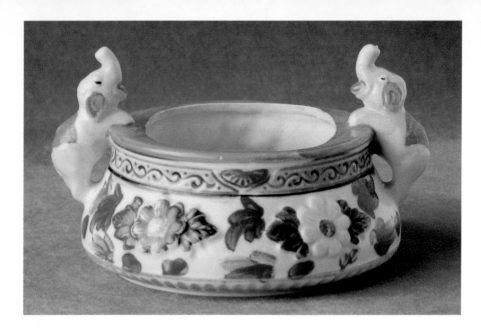

This planter is fairly large but shallow. There is a very pretty flower painted on the bottom of the inside. The bowl is 6 inches in diameter, it would make a nice fish bowl or candy dish.

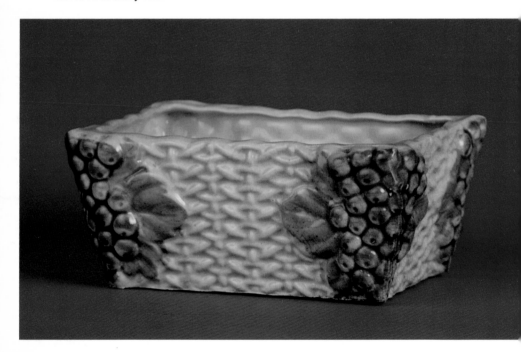

A 6-1/2 x 4-1/4 inch planter that was used a lot--probably because it is such a nice size.

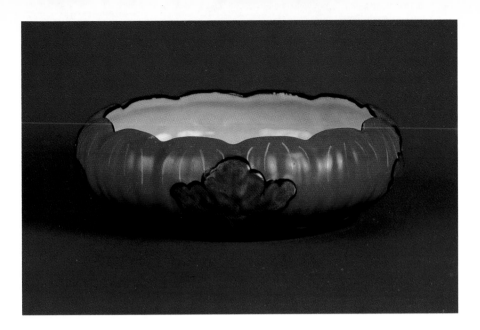

Hand-painted shallow planter, 6 inches in
diameter. This would be a nice bowl to set
one of those pretty flower arrangers in.

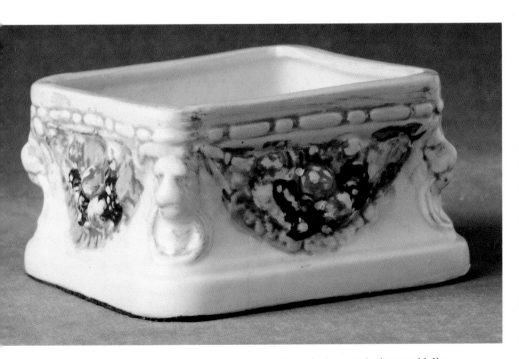

An elaborately decorated planter with lion
heads on the corners. This piece measures
6 x 6 x 3-1/4 inches and is unmarked.

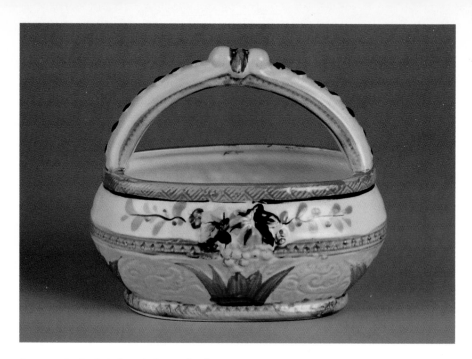

An attractive basket-shaped planter that is
7-1/2 inches long and 4 inches wide.

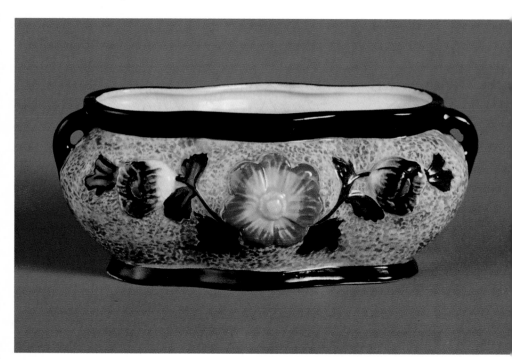

A different type planter, this is almost too
pretty to use. This measures 3-1/4 inches
high and is 7-1/2 inches long.

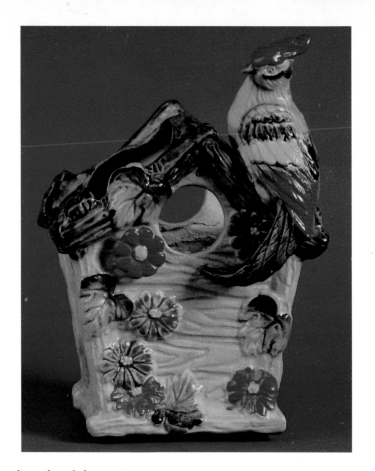

This piece is gaudy and always attracts a comment.

This colorful rooster is 7 inches tall and looks like an expensive piece of majolica until you look at his comb. Unlike the rest of his body, the comb is painted and unglazed.

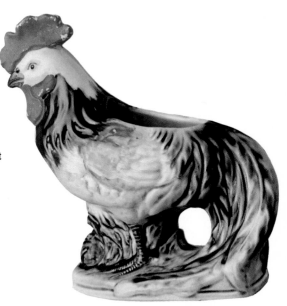

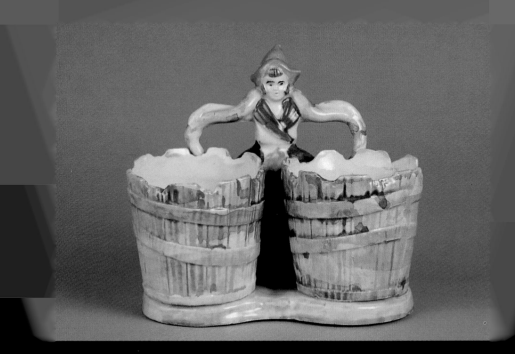

A double planter is a bit unusual--this one
is 5-1/2 inches tall and 6-1/2 inches wide.

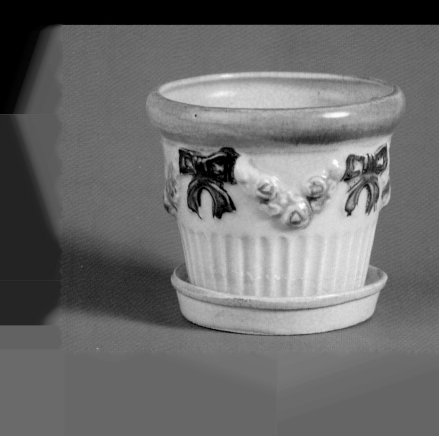

A pretty 5-inch, scalloped edge pot would look nice with an african violet planted in it.

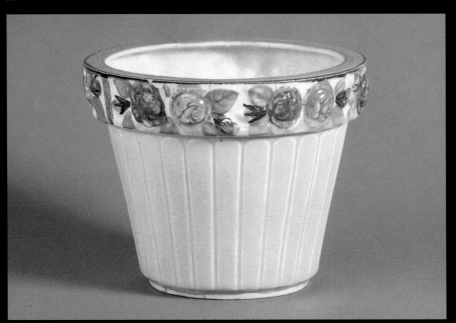

This flower pot is 4-1/2 inches tall and is 5-1/2 inches in diameter. These flower pots do not have drainage holes, water carefully!

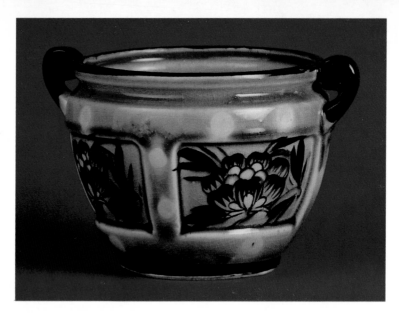

A highly glazed, 4-inch x 4-3/4 inch
handled bowl or pot that has hand-painted
flower panels and is very nicely made. If
this were a larger piece, it would be a
beautiful jardiniere.

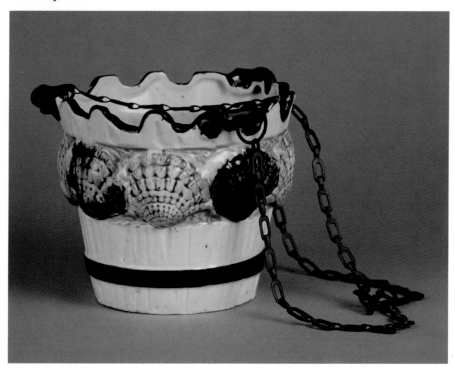

Something different--a large planter with
chains for hanging.

17. Plates and Serving Pieces

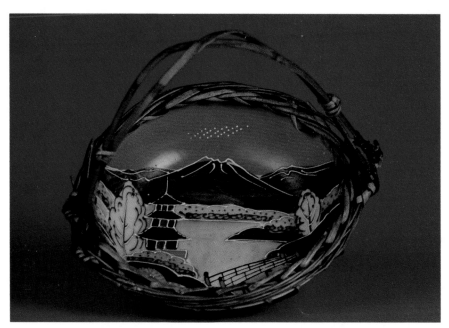

A nice little wicker-handled dish, very colorful.

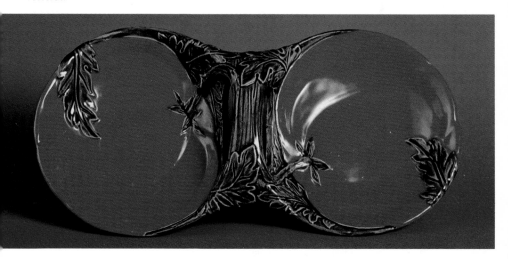

This handled serving piece is quite large, measuring 11 inches in length and 5-3/4 inches wide.

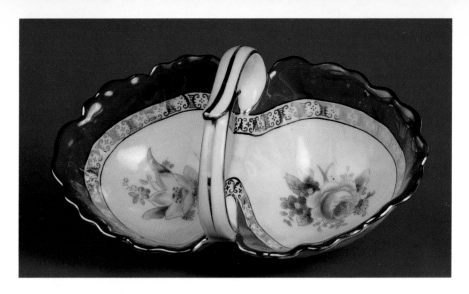

A Noritake hand-painted divided dish that measures 6-1/2 x 4 inches and is 3-1/2 inches tall, including handle.

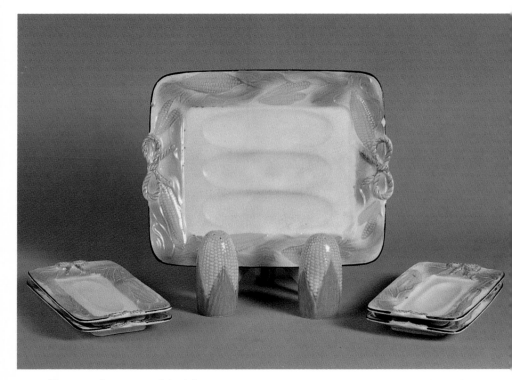

European, Japanese, and American potters have been making items with a corn motif for many years. This Japanese set has evidently seen much use--and why not, it is a pretty nifty way to keep those roasting ears out of the mashed potatoes and gravy! The tray measures 8-1/2 x 11 inches and the individual plates are 4-1/4 x 8 inches. The salt and pepper shakers are 3-1/2 inches tall.

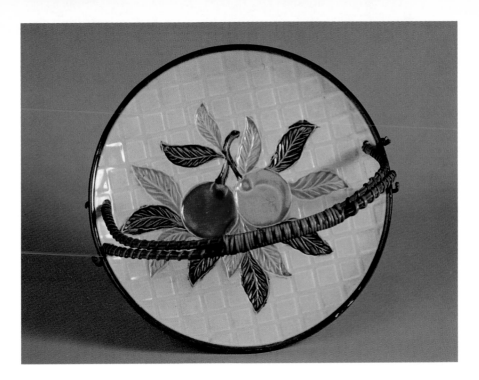

This large plate measures 10-3/4 inches
across and with the wicker handle, would
make a very nice sandwich server.

Beautiful 7-1/2-inch plate that is much
heavier than any other plates of similar
size.

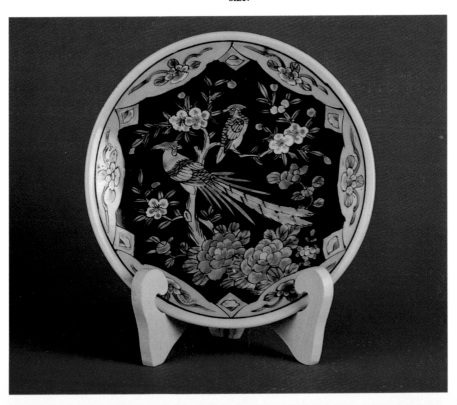

Hand-painted dish. The dish is 3-3/4 inches and matches the lovely hand-painted swans shown in the section on planters.

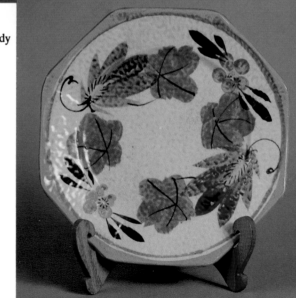

An unusual 6-3/4 inch open relish or candy dish with luster finish.

A pretty little plate, it is 7-3/4 inches across.

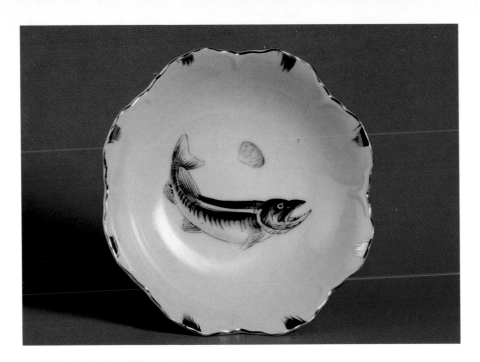

Nice little 6-inch plate. This may have
been part of a fish set.

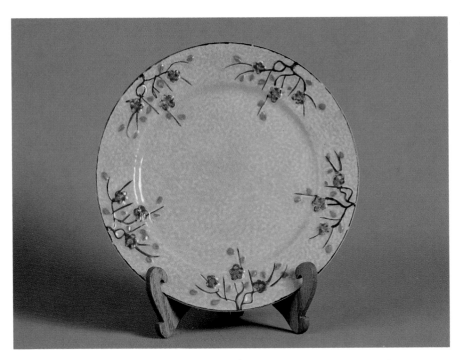

This pattern was made in many different
pieces but in all cases, the crazing is
extreme.

You might call this a mystery bowl. It measures 2-1/4 inches in height and is 4-1/4 inches wide. It is a bit large for an individual custard bowl and rather small for a pudding mold.

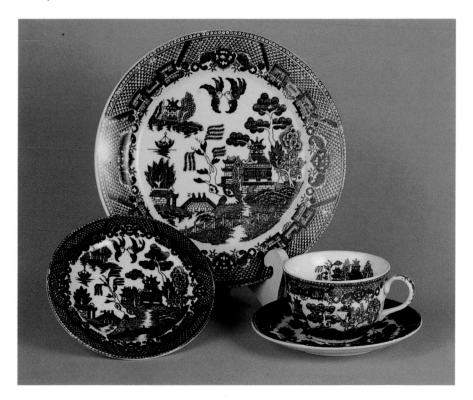

A place setting of Willow dinnerware. English versions of the Willow pattern have an inner border, this Japanese version does not. The dinner plate is 9 inches in diameter, the bread and butter plate is 6 inches.

18. *Reamers*

Reamers are used to squeeze oranges to extract the juice.

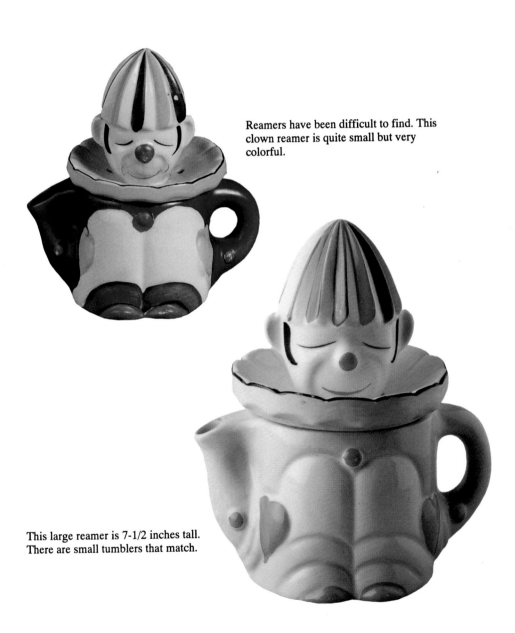

Reamers have been difficult to find. This clown reamer is quite small but very colorful.

This large reamer is 7-1/2 inches tall. There are small tumblers that match.

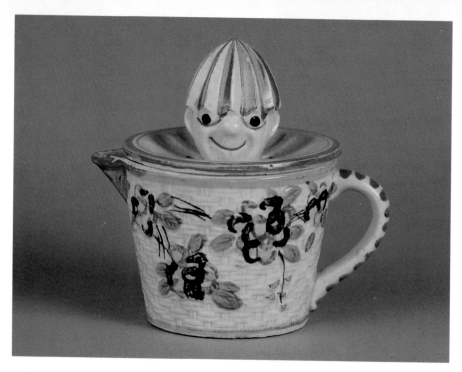

This cheery clown "ain't got no body," he seems to be floating in the juice pitcher. He still makes a nifty addition to a reamer collection.

A large reamer--it would take several oranges to fill this one as it is 7 inches tall and 5 inches in diameter.

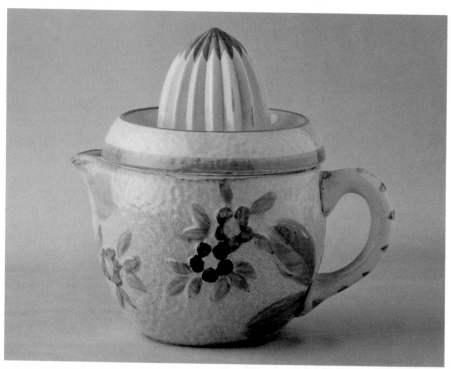

19. Salt and Pepper Sets

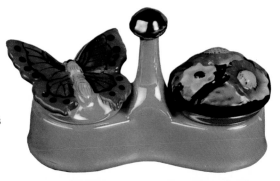

A salt and pepper set that was just too pretty to resist. Flowers and butterflies have a special appeal.

These are individual salt and pepper shakers. Salt is held in the bottom bowl half and pepper is held in the top shaker. Since they are rather unique, another view is shown to better explain how they are made. The pieces have a luster finish and are quite colorful. The turkey is 2-1/2 inches tall, the bird is 3 inches tall.

Back and separated views of the individual salt and pepper shakers. The back of the turkey shows the slot that accommodates a small ceramic spoon to dispense the salt. The top half of the bird on the right shows the cork that holds the pepper intact. If you try to describe these verbally, it gets a little tricky, so a picture is worth a thousand words.

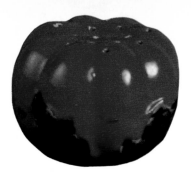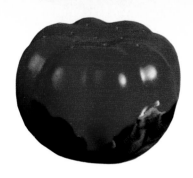

Salt and pepper shakers in the tomato pattern. You may find a small tray for the salt and pepper sets, in one of two versions: one is a green leaf-shaped piece, the other is a red rectangular piece with a green border. There are larger shakers and some may have more leaf decoration than those shown.

These salt and pepper shakers are quite large, they were probably part of a "range set" that included a drippings jar and other pieces.

Another large salt and pepper set. Salt and pepper shaker collecting is a whole field in itself. Many good reference books are available for reference. Only a sample of the novelty and utilitarian types is shown here.

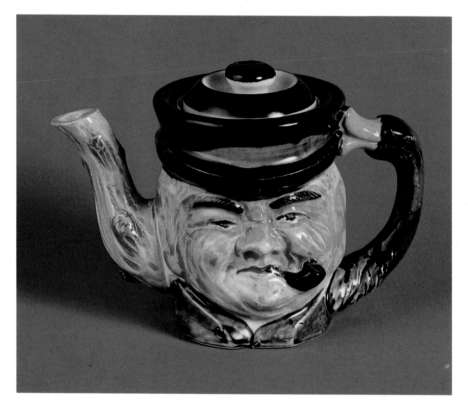

Now this is a man's teapot!! Note the duck
head handle, reminds you of Royal
Doulton handles, doesn't it?

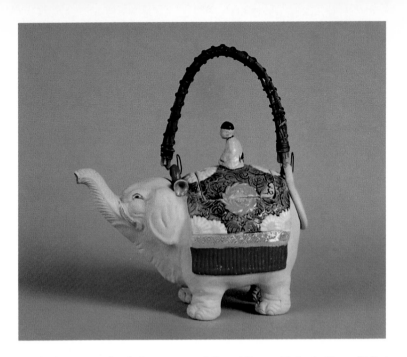

Finding an elephant teapot that isn't damaged will take some hunting. This little fellow is 8 inches long from trunk to tail and stands 7 inches tall, including the fellow riding on his back. You will find different versions of the elephant, some are quite plain, some have very lavishly decorated blankets and much gold trim.

An unusual design for a teapot, it has a nice rugged look about it, nothing "cutesy".

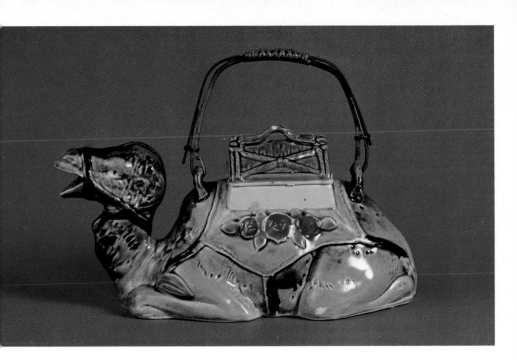

The camel teapot catches everyone's eye!
He is 10 inches long and is 5-1/2 inches
tall laying down. Glad he isn't standing, he
would sure be one awkward looking
teapot!

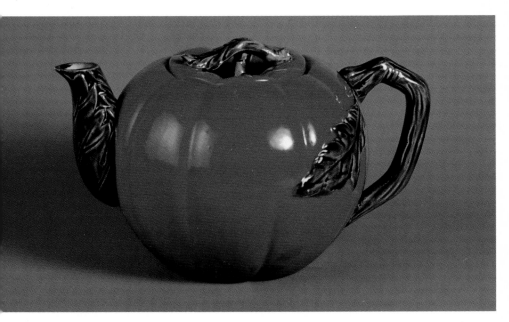

Reminds you of the Royal Bayreuth
tomato pieces, doesn't it? The workman-
ship and glaze is excellent on these pieces;
however, the red is a deeper and richer
shade than the Royal Bayreuth pieces. The
teapot holds 44 ounces.

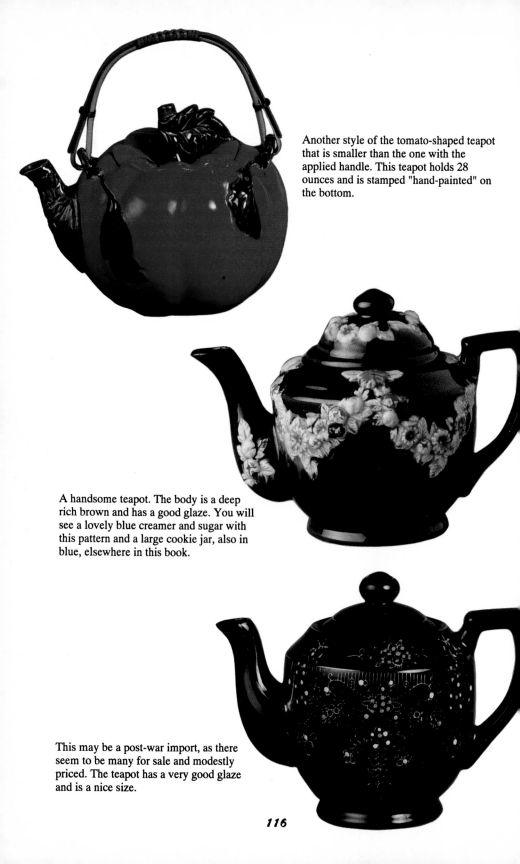

Another style of the tomato-shaped teapot that is smaller than the one with the applied handle. This teapot holds 28 ounces and is stamped "hand-painted" on the bottom.

A handsome teapot. The body is a deep rich brown and has a good glaze. You will see a lovely blue creamer and sugar with this pattern and a large cookie jar, also in blue, elsewhere in this book.

This may be a post-war import, as there seem to be many for sale and modestly priced. The teapot has a very good glaze and is a nice size.

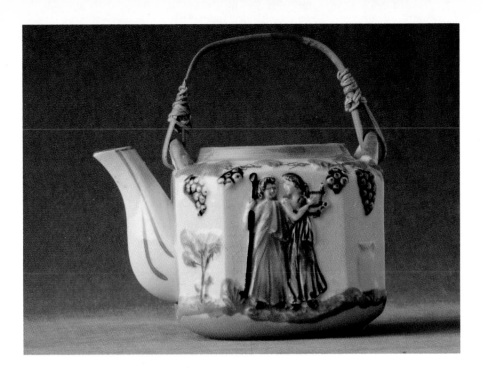

This 4-1/2 inch teapot is so pretty even
though it does not have its lid any longer.
Flower arrangements are lovely when
displayed in pieces such as these.

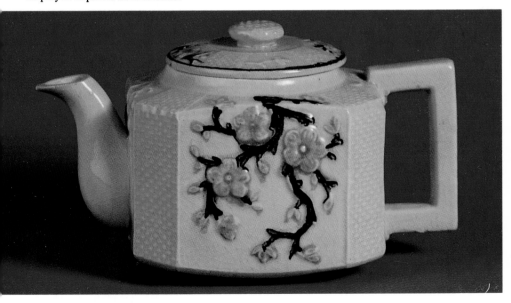

This conventional teapot is 4-1/2 x 5
inches long and 5 inches tall. The pattern
seems to have been quite popular as it
appears on several pieces. This pattern is
embossed on the teapot pictured here, but
you will see it again on a pitcher and salt
and pepper shakers elsewhere in this book
where the design is merely painted on to a
smooth surface.

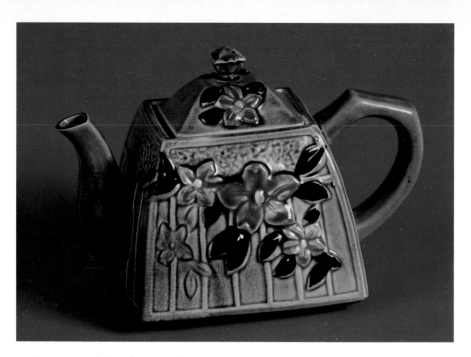

Another commonly found teapot with a
nice glaze. Certainly not a novelty item,
this pot was intended to be used.

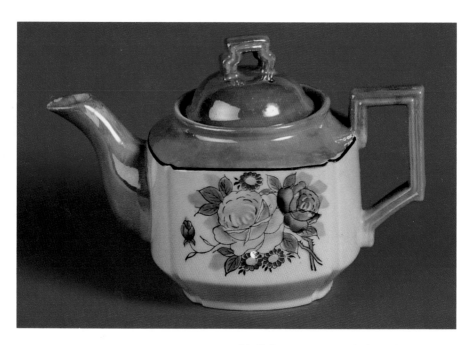

This little two-cup teapot belonged to my
spinster aunt who may have used tea bags,
but the tea had to be brewed in a pot.

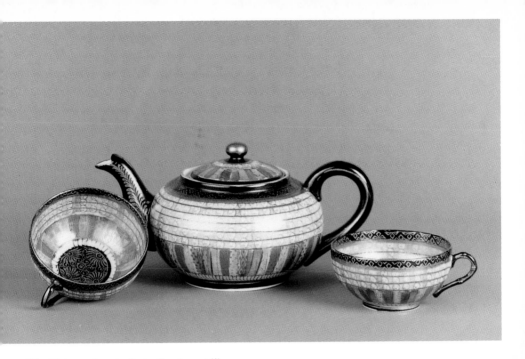

Wouldn't you love to find a fine tea set like this one for yourself? The teapot is 4-1/2 inches high and 6 inches in diameter, the cups are 2 inches tall and 3-1/2 inches wide.

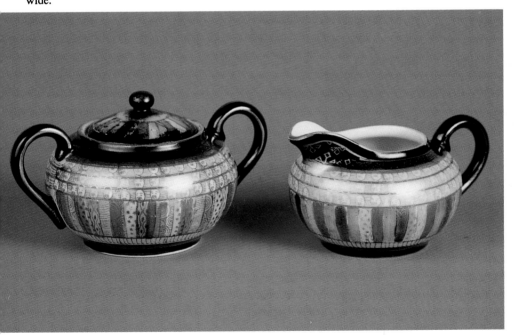

The creamer and sugar are 3 inches high. Plates and saucers complete this set.

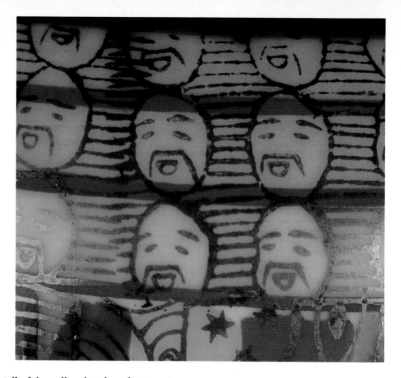

A detail of the yellow band on the teapot.
A thousand faces, all just a bit different.

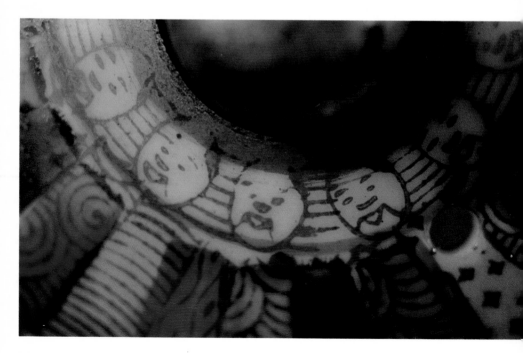

Detail of the teapot lid where there is a
band of the faces.

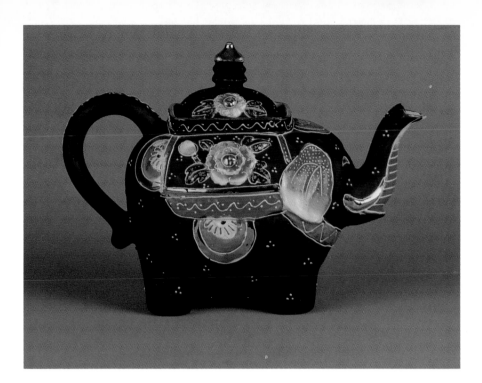

A lovely Satsuma teapot, quite large, and very well decorated. Teapots such as this are a very nice to find.

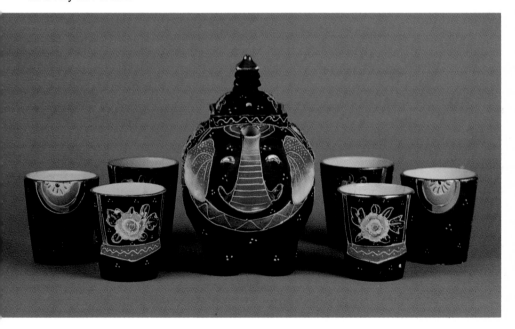

The teapot with its matching cups. Note that the design on the cups is different on the back.

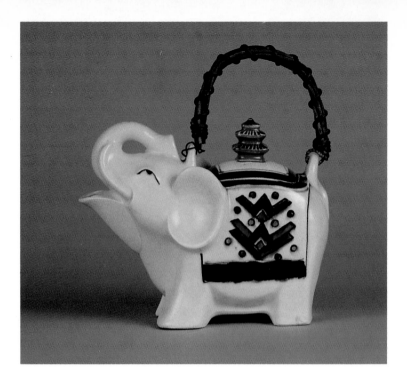

Another version of the elephant teapot.
This elephant is 8 inches tall.

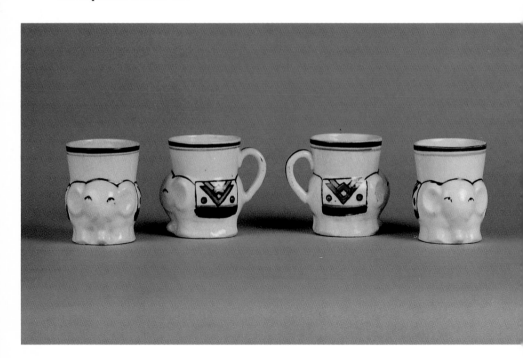

The matching cups with handles. These
cups are 3 inches tall.

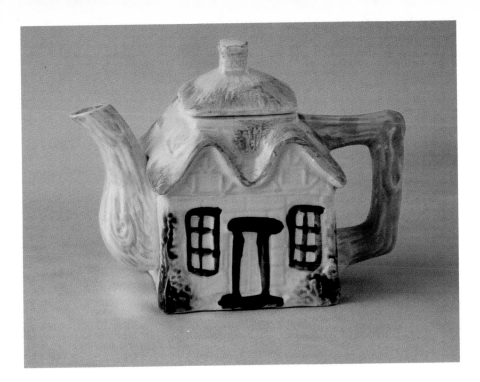

Bungalow or house teapots are nice additions to a collection. This bungalow has an interesting roof detail. It is 5-1/2 inches tall with a 3-1/4-inch base.

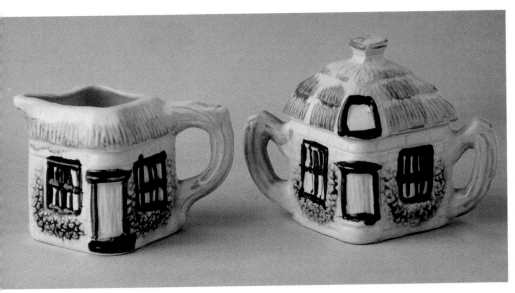

At first glance, this creamer and sugar would seem to match the teapot, but the placement of the door on the corner rather than on the side, and the different roof design makes me wonder. You will find windows with different numbers of panes on these pieces.

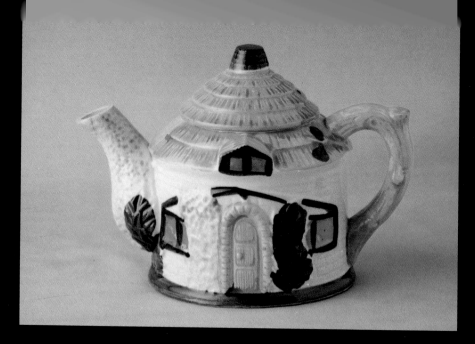

This teapot is very poorly painted. While the style is similar to other bungalow teapots, a closer study reveals that the spout, number of layers of "shingles" on the roof and the knob on the lid are all quite different.

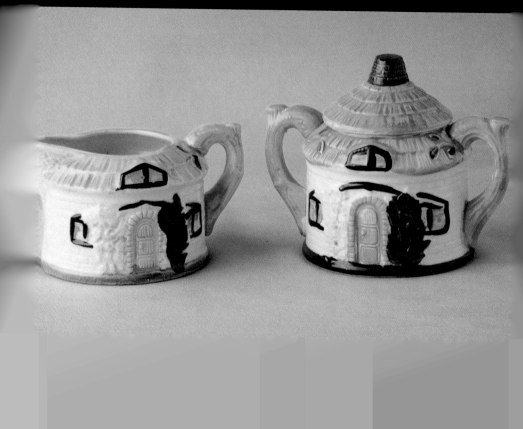

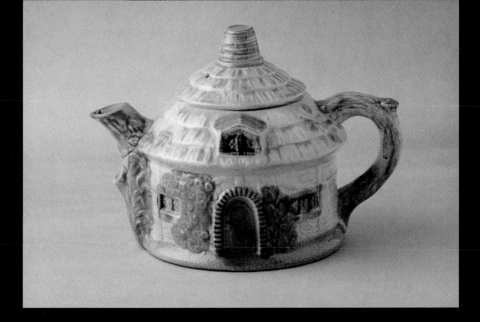

Another little bungalow teapot that would
be a prize in any collection. The teapot is 6
inches tall and 5 inches in diameter.

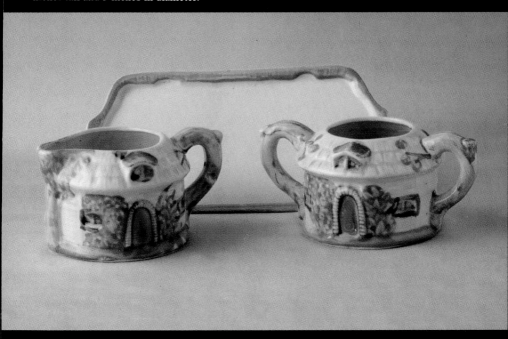

Finding the matching bungalow-shaped
creamer and sugar was easy, but finding
the matching tray was more difficult.
Creamer and sugar are 3 inches tall, tray is
8-1/2 inches long.

This 5-1/2 inch windmill teapot was a souvenir of Holland, Michigan. Every year thousands of tourists flock there for the annual tulip festival and buy souvenirs made in Japan.

This windmill teapot is comparatively large, 5-1/2 inches tall with a 6-1/2-inch base. The lid on this teapot is similar to the lid of the other windmill teapot shown herein, so I suspect both were made by the same manufacturer.

Matching windmill sugar and creamer. The salt and pepper shakers were found among a salt and pepper collection at a flea market several months after the other windmill items were purchased. The creamer is 3 inches tall, the sugar is 5 inches tall and the salt and peppers are 2-1/2 inches tall.

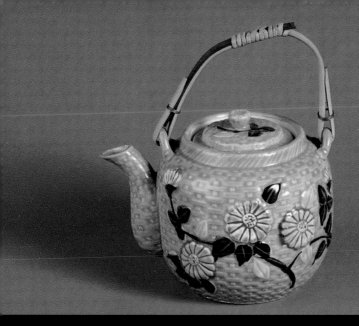

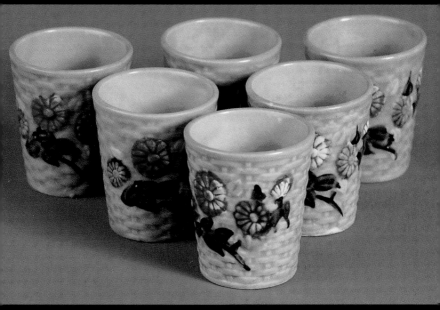

his pretty teapot and matching cups is
ery similar to another set that you will be
eeing, a closer look will show some

variations such as round lid, different
flowers, etc. Also, the basketweave
patterns are different

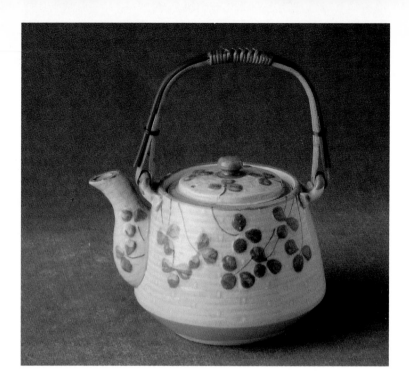

The ivy pattern is used to decorate many kitchen items such as this rather small teapot, which is only 4-1/2 inches tall. Once you start looking for a particular pattern, you may find matching cookie jars, pitchers, or salt and pepper shakers, just be prepared for surprises!

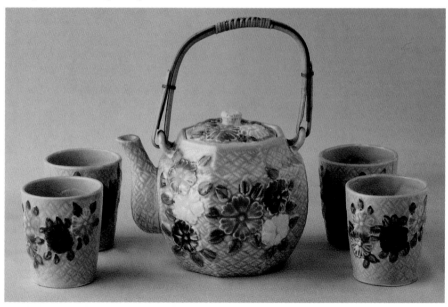

Teapots and matching cups are a great find. This set is very nice, the colors are pretty and the painting has been done very well. Cups without handles such as these are common.

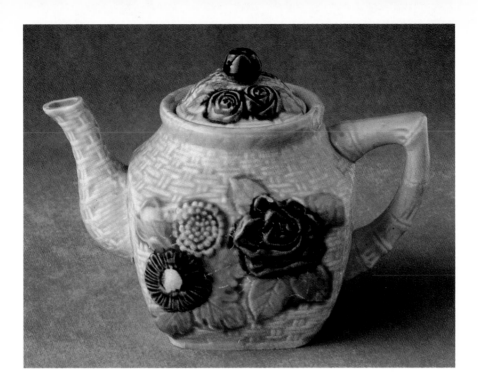

Another of the more common teapots you will find. These simpler teapots seem to have been used a lot and finding one without chips is the trick here. This pot is 6 inches tall.

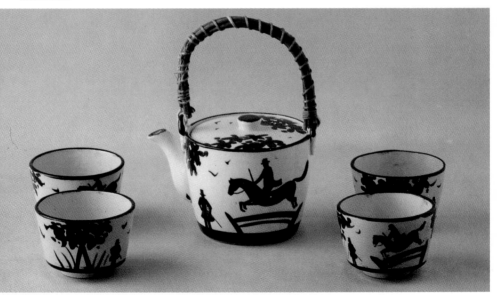

This tea set is quite different. The hunt scene in black on a white background is very attractive. The teapot is quite small, only 3-1/4 inches tall and 4 inches in diameter. The cups are 2 inches tall and hold 4 ounces.

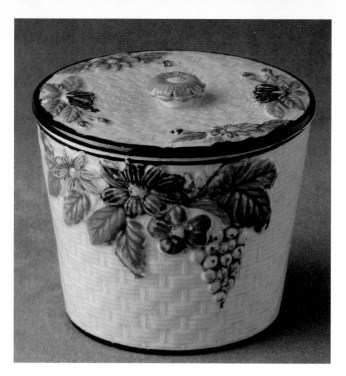

This large covered container may have been intended to be for loose tea or used as a "drippings" jar. Thrifty housewives saved fat from bacon, etc. in jars such as these and used the fat to fry potatoes and other foods. They also collected fats to make homemade soap, this practice continued through World War II, when commercial soap products were in short supply.

Typical kitchen items made during this 1921-1941 time frame. The cream pitcher is 4 inches tall, the covered bowl (sugar?) is 2-1/2 inches. The covered jar is 5 inches tall and could be either a loose tea container, a cookie jar or a drippings jar; it is larger than most drippings jars.

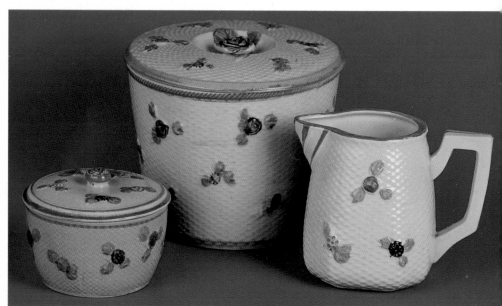

Little clown tea bag holder.

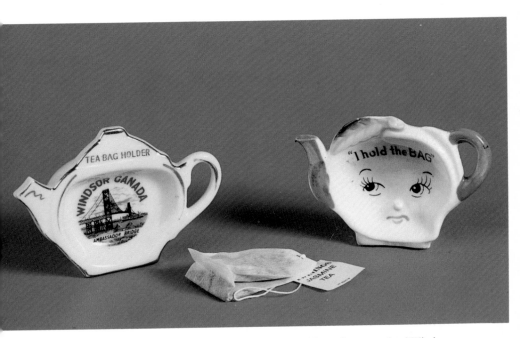

Tea bag holders--the souvenir of Windsor, Canada, was found in a landfill in Indiana and believe it or not, in pretty good condition!

21. Toothpick and Match Holders

The holder on the left is a toothpick or match holder and is 2-3/4 inches tall. The holder on the right is 4 inches tall. How can you tell a toothpick or match holder from a planter? Planters usually have irregularly molded interiors, the match holders and toothpick holders have smooth interiors and are shaped like a small tumbler or cup. This is not an infallible rule, but may help you identify the intended use of some of the smaller items you will find.

This pretty little luster toothpick holder would go well with a couple of individual salt/pepper shakers that are shown elsewhere in this book. This holder is 3 inches tall.

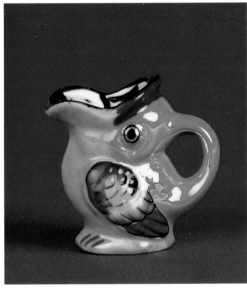

Musical mouse guarding the holder. The mouse is 2-5/8 inches tall.

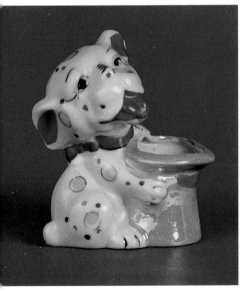

A 3-inch shell seems mighty big for that little duck, but it makes a very nice match or toothpick holder.

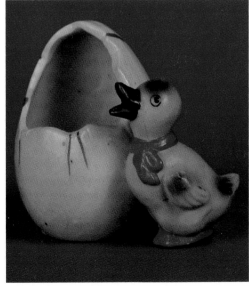

Happy little pooch, isn't he? There are a lot of toothpick and match holder collectors and prices are driven by supply and demand. Expect to pay quite a bit for the more unique or prettier ones, and even the plainer holders are just not all that plentiful.

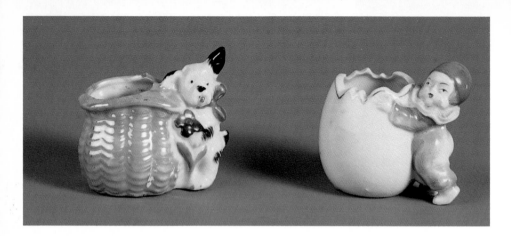

These two little treasures are either toothpick or match holders. How do you tell a match holder from a toothpick holder? My theory is, if it is filled with matches, it is a match holder, if it is filled with toothpicks, then it is a toothpick holder. If it is empty, you can call it what you wish. Works for me.

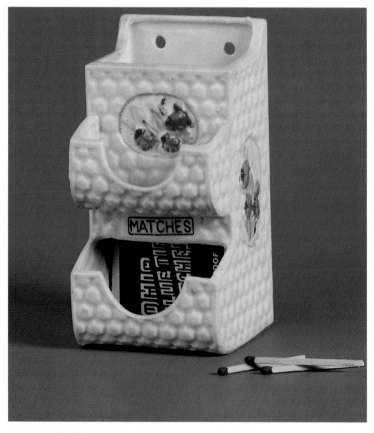

Kitchen match box holders are not easy to find and are expensive. This one has holes for hanging on the wall, a compartment for burned matches, and the bottom of the holder is ridged for striking the matches. Pretty handy gadget, this is one piece I keep in my kitchen and use frequently. The holder is 6-1/2 inches tall.

22. Vases

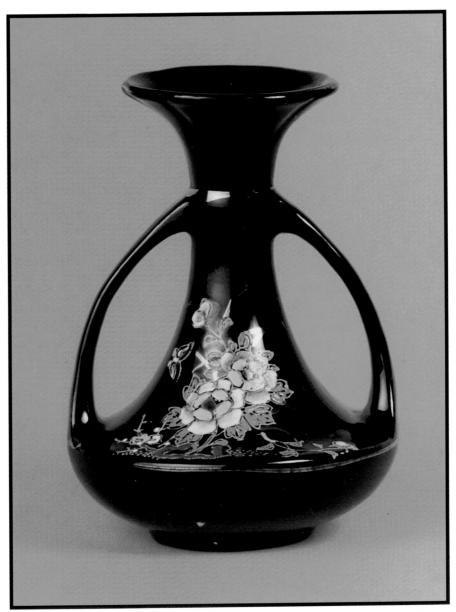

A 6-1/2 inch hand-painted vase that is
beautiful as is, but can't you just picture a
few white roses in it?

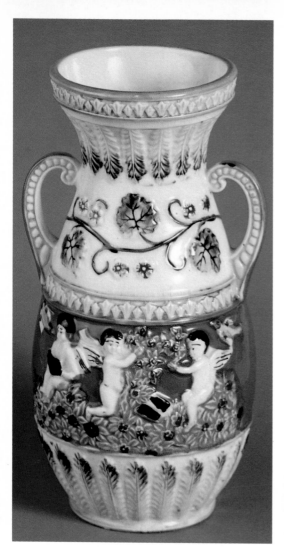

This large and pretty vase has a matching cookie jar shown elsewhere in this book. Expect to pay more for workmanship and detail such as this. The vase is 10-1/2 inches tall.

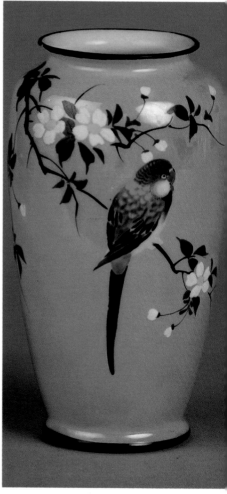

Very nice 6-1/4 inch luster vase with hand-painted bird.

Unusual 3-1/2 inch double vase. The workmanship on this piece is nicer than one would expect to find on a small novelty item such as this.

This 6-1/2 inch vase is as pretty from the back side as from the front.

Two of the smaller vases--both with three handles and the design covering all sides. The vase on the left is 3 inches tall, the one on the right is 5 inches.

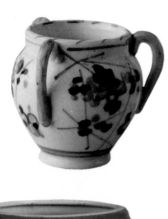

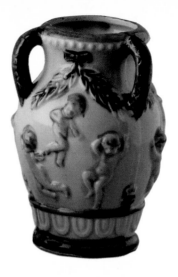

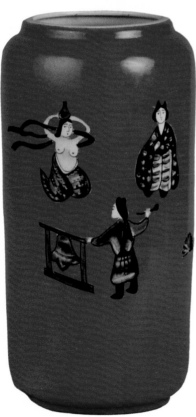

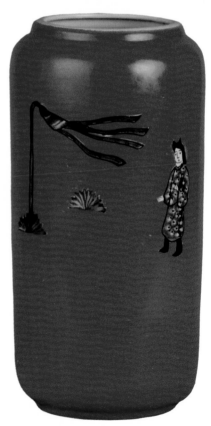

This lovely 10-1/2 inch red vase is quite unusual and can be appreciated more if you can see both the front and back views.

Back view of the vase shown above. If the topless lady on the front side is too risque, you can always display this side.

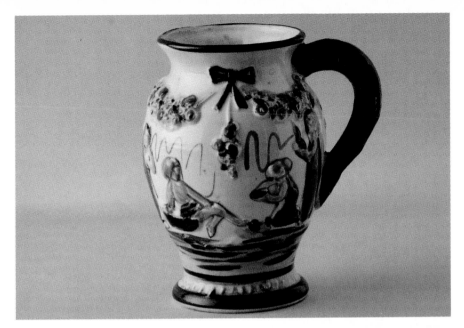

Urn, ewer, vase, call it what you wish, it is 6 inches tall and very attractive.

An elaborately decorated 5-1/2 inch vase, the colors are pleasing.

Interesting 5-1/2 inch vase with alternating bands of basketweave and plain background. The medallion of embossed flowers on a dark blue background is a different touch.

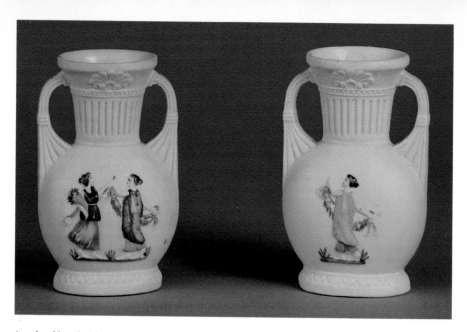

A pair of lovely bisque vases that are 4-3/4
inches tall. The front and back sides of the
vases are different.

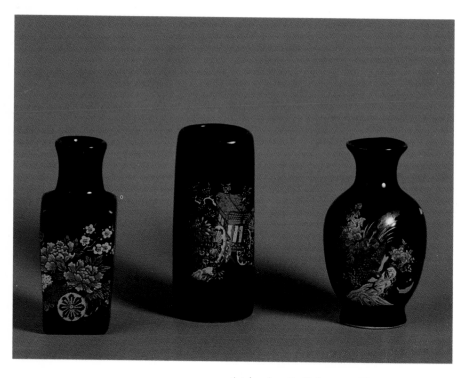

A trio of pretty little vases. These are
about 3 inches tall.

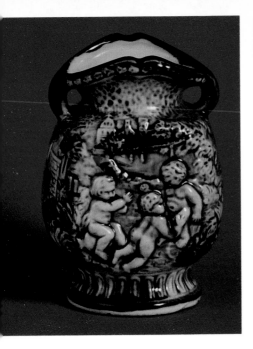

This vase is only 4 inches tall and the perfect size for that little bouquet of violets your small child just spent hours picking for you.

Pretty vases such as these are not hard to find and prices should be reasonable.

Three small vases that are typical of those you will find quite readily. The vase on the left is about 2-1/2 inches tall.

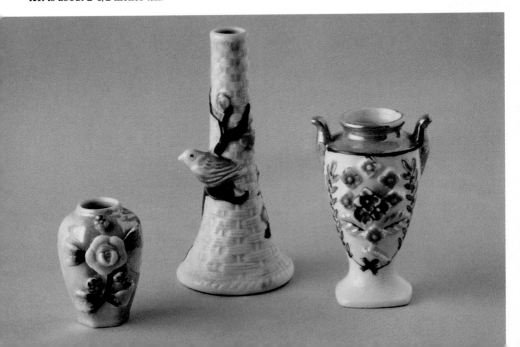

This 3-3/8 inch dog could be sitting beside a planter, but it probably is a vase; it is too narrow and deep for a practical planter.

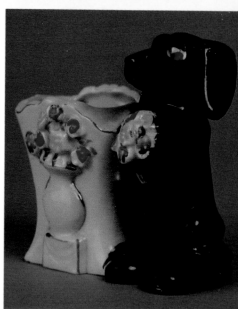

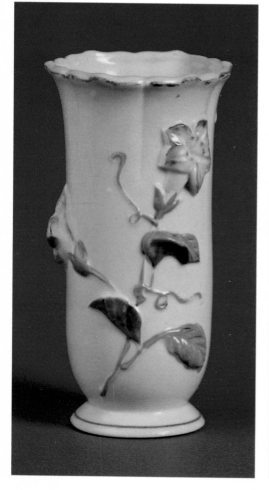

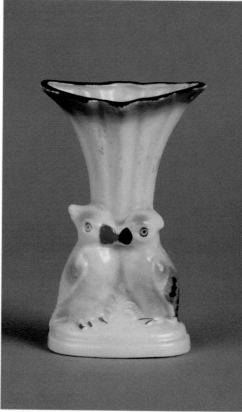

Vase with applied flowers--very nicely finished and painted.

Nice 5-inch vase, typical of the vases that are in good supply and modestly priced.

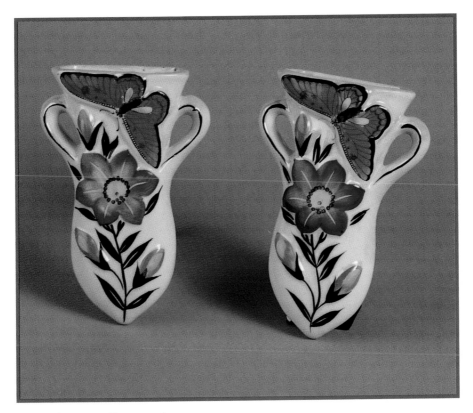

Wall pockets, or wall vases as they are
sometimes called, are seldom found in
pairs. This pair is in perfect condition, and
aren't they pretty? These vases are 6 inches
high, which seems to be the average size
for wall vases.

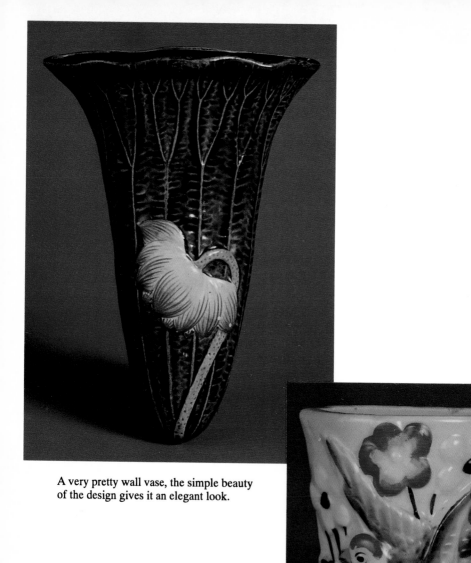

A very pretty wall vase, the simple beauty
of the design gives it an elegant look.

A very colorful wall vase that would have
been much prettier if the painting had been
done more carefully.

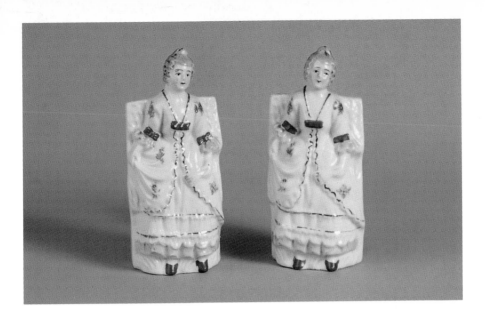

These wall vases are a bit different in shape than is usually seen; they can also be used as planters on a table or shelf because the bottom is flat.

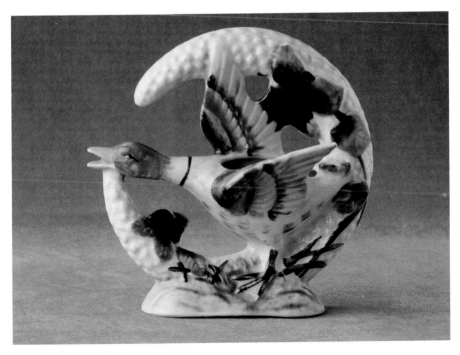

This planter is designed to be hung on a wall or set on a shelf or table. It is pretty wherever you choose to use it. Although the mark is "Made in Japan," the colors and workmanship suggest this may be a newer piece.

A much nicer vase--it is 6 inches tall and
even prettier than the picture shows.

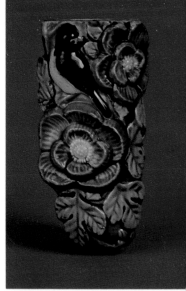

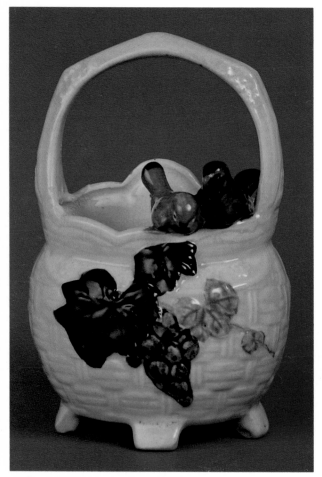

Another wall vase that can be hung or
rested on a table or shelf. This piece is
6-1/2 inches tall and rather pretty, despite
the poor paint job--those black grape
leaves look severely blighted to me.

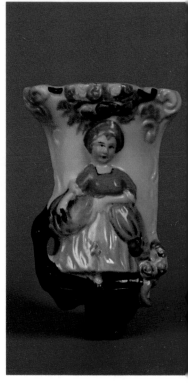

My favorite wall vase, a pretty little girl
sitting under a bower of flowers. This vase
is 6-1/2 inches tall.

Section 3.
Identification Markings

Except as noted, the pieces shown in this book bear marks reading "Made in Japan". These marks were applied at the factories in Japan to identify the objects made for export to the United States during the period 1921 through 1941. These marks may be stamped (an ink marking), embossed (raised design or relief) or incised (cut into, engraved).

Although some paper labels may have been used during this period, it has not been possible to verify this. Very few unmarked pieces have been found that are characteristic of the 1921 to 1941 era.

There have been instances of deliberate efforts to sand off markings or to apply an acid to erase the ink stamp-- both with very poor results.

Many of the items marked "Made in Japan" but sold later in the "Made in Occupied Japan" era will be marked "Made in Occupied Japan" on a paper label. Once that paper label is lost, collectors and dealers will have to rely on their

1.

experience and powers of observation. This should not be a major problem; the differences between old (1921 to 1941) and new (after 1952) "Made in Japan" pieces are quite obvious, once they compare a few pieces of each.

Using the mark "Made in Japan" (whether stamped, engraved, or incised) has proven to be a fairly reliable means of dating the older Japanese imports--but there are a few variations. For example, a teapot may be embossed "Made in Japan" and its matching creamer and sugar embossed simply "Japan." If the three pieces are identical in coloring and painting technique, there is little doubt that all pieces were made at the same time.

Another variation is seen in the markings on a creamer and sugar with matching tray. The sugar and creamer are incised "Made in Japan", and the matching tray is incised "Made in Japan" but is also stamped "Made in Japan". No doubt you will find similar inconsistencies. These differences illustrate how difficult it is to formulate a hard-and-fast rule for identifying the older "Made in Japan" pieces by marks alone.

All this may sound confusing, but don't let it discourage you. After handling hundreds of "Made in Japan" objects, workmanship and "feel" of the older pieces becomes quite evident. You will soon become familiar with this look and feel as you build your collection.

Unless you plan to display all your lovely treasures upside down, don't get too hung up on marks! Display and enjoy your collection for itself and not the markings. If you find a newer piece of Japanese ware that you like, by all means

2.

3.

buy it and treasure it. If you see what appears to be an unmarked piece that you feel sure should be marked "Made in Japan" or "Japan", look closer. The markings may be hidden on the sides or top of the base of an object, the inside of a vase, or inside the hollow base of a figurine.

Dealers continue to argue at length about which is the older backstamp--the black ink or the red ink stamp. Pieces also are found with green ink and blue ink stamps. Frankly, color seems to have little to do with dating the time of manufacture. There were no export laws governing the color of ink; the decision to use a certain color was more likely the whim of the manufacturer.

Photos of some of the more distinctive markings on pieces shown in this book are following. Unfortunately, little information is available to identity the companies who used these backstamps or the years during which these backstamps were used.

Many questions remain. Wouldn't it be interesting to know the histories of the companies and whether any are still in operation today? Was much of the painting on the little novelty items done at home, as "cottage industries"? Was the painting on the objects done by men or women, and were children employed? Some of the pieces were obviously done by highly skilled workers, how were they employed?

4.

5.

6.

7.

8.

9.

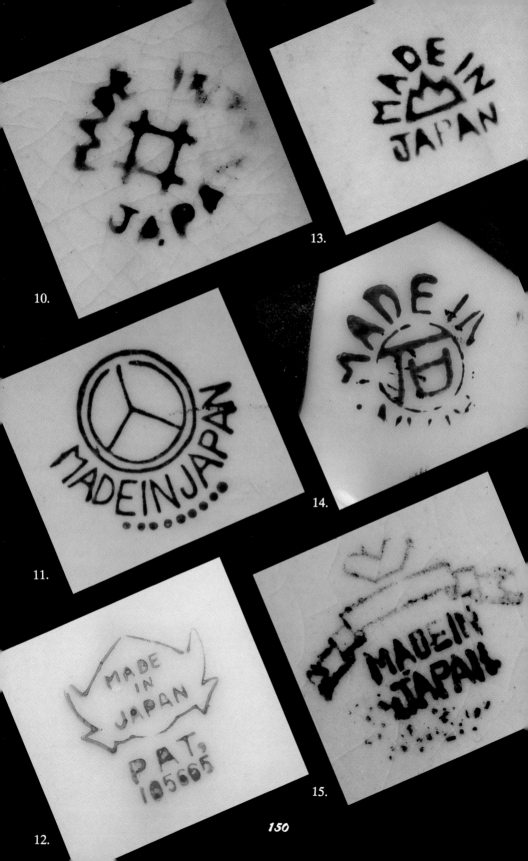

10.

11.

12.

13.

14.

15.

150

MADE IN JAPAN

MANU PAINT · MADE IN JAPAN

MADE IN JAPAN

ELITE · MADE IN JAPAN

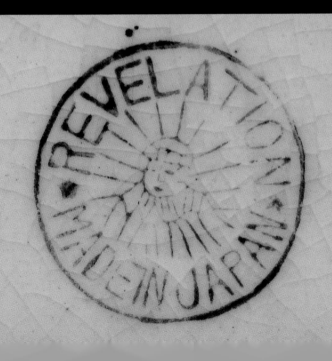

REVELATION · MADE IN JAPAN

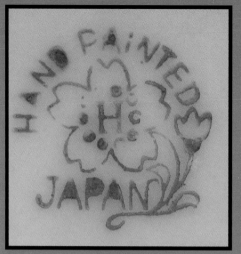

21.

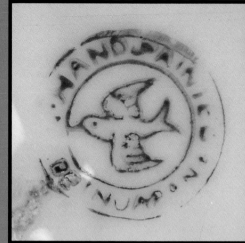

25.

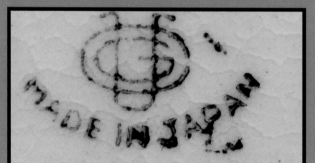

22.

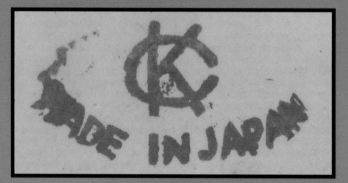

23.

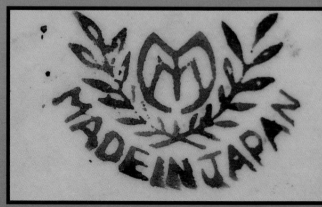

24.

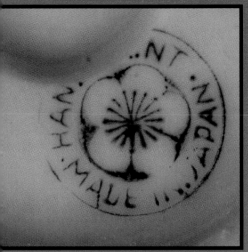

26.

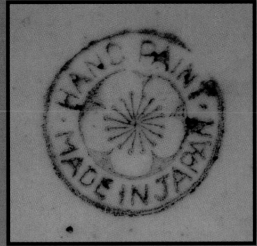

29.

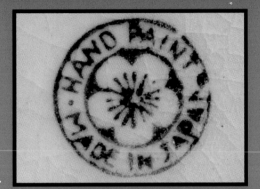

27.

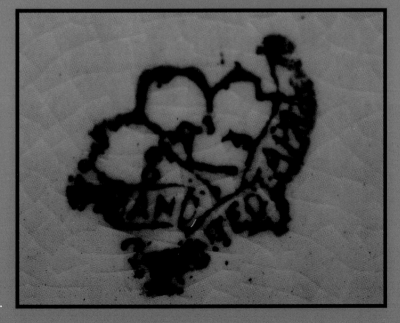

28.

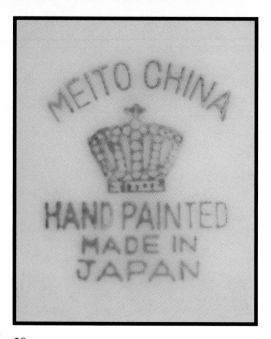

MEITO CHINA
HAND PAINTED
MADE IN
JAPAN

30.

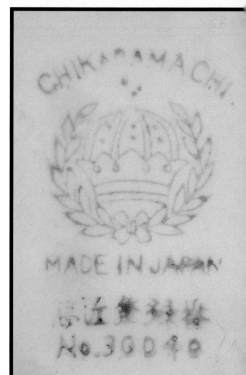

CHIKARAMACHI
MADE IN JAPAN
No.30040

32.

MADE IN
JAPAN

31.

MADE IN JAPAN
PIONEER. MUSE

33.

Price Guide

Everyone loves a bargain! The popularity of price guides is due in part to the fact that once a price guide is issued, it becomes a yardstick whereby we can compare prices asked with some documented source that we construe as an assessment of actual value. Undeniably, price guides do serve a useful purpose, but they should not be quoted as bibles.

The prices quoted herein reflect actual prices I have paid or a range of prices observed for similar items that were for sale at various antiques malls or shops. Bear in mind that many factors influence prices.

Prices vary widely in different parts of the country. Most items shown in this book reflect the offerings of dealers from several states through a large variety of flea markets and shows. Prices in your area may be higher or lower.

Supply and demand is the biggest factor in pricing any collectible, whether antique or contemporary. For example, there are many collectors of pitchers--at present, the supply is adequate and the prices remain stable. There are also many collectors of reamers, but there is not an abundance of reamers to be found. Consequently, the price of reamers continues to escalate.

Condition should always be a consideration when buying. A crack will never mend, a chip will never heal--buy the best pieces that will appreciate in value over time. This does not mean that you will find "mint condition" in every item, most of the items shown in this book range from 50 years to over 70 years old--many were souvenir or novelty items and were not handled gently through the years.

Nostalgia and sentiment play a major part in assessing a value. A customer may buy that "little teapot just like Grandma's" and consider it a bargain at $30.00. Another dealer may carry a similar teapot and watch it grow dust for months with a price tag of $10.00. Without a sentimental value, the little teapot is just that--a little teapot.

Prices asked at antiques malls and shows reflect a dealer's overhead (booth rent as well as travel expenses such as gasoline, food, and lodging) that are incurred. An item found at a garage sale may cost only a dollar but when bought from a dealer may cost $5.00, and the person holding the garage sale may make the higher percentage of profit!

Rarity plays a large part in assessing values of antiques and collectibles. So few duplicates of the pieces shown in this book have been seen that the word "rarity" has little meaning here. When collecting "Made in Japan" items becomes established as a recognized collecting field, items that are truly rare may become evident. "Made in Japan" items were imported by the boatloads, and who knows what treasures those boats held! Only time will tell.

Hand-painted items, the amount of gold embellishment, size, and collectibility (Disneyanna figures, teapots, etc.) are all a consideration of pricing.

For now, enjoy your hobby, buy what you like and pay only what the item is worth to you.

DISCLAIMER NOTICE

Prices quoted in this book are not intended to be used to set prices. Auction prices and dealer prices are determined by demand, condition, and even wistful thinking! Prices may vary widely in different parts of the country. Neither the author nor the publisher shall be held responsible for any losses incurred through the use of this guide.

To illustrate how widely prices can vary, check out the little novelty item at the bottom of page 16. This was purchased at a flea market for $2.50. An identical piece was seen at an antiques mall (in a locked case) with a price tag of $37.50! How much would it be worth to you?

Location codes: T=top; C=center; B=bottom; L=left; R=right; FP=full page.

Page	Description	Location	Value
2	Bell	—	$15.00
8	Epergne	L	15.00
8	Epergne	R	15.00
9	Sake Set	T	10.00
9	Sugar Shaker	BL	10.00
9	Single Candle Holder	BR	3.00
10	Burro/Egg Cup	T	10.00
10	Candle Holders (pair)	B	15.00
11	Kutani Cat	T	*
11	Cookie Jar	B	25.00
12	Ashtray (Rose Medallion)	T	15.00
12	Novelty Ashtray	B	10.00
13	Novelty Ashtray	T	10.00
13	Individual Ashtrays (each)	B	3.00
14	Novelty Ashtrays (each)	T	5.00
14	Novelty Ashtrays (each)	B	5.00
15	Novelty Ashtray	TL	5.00
15	Novelty Ashtray	TR	8.00
15	Novelty Ashtray	B	8.00
16	Cigarette Holder	T	12.50
16	Novelty Ashtray	C	10.00
16	Ashtray ('Pon My Sole)	B	*
17	Novelty Ashtrays (each)	T	5.00
17	Novelty Ashtray	C	5.00
17	Ashtray	B	12.50
18	Bookends (pair)	FP	35.00
19	Bookends (pair)	B	20.00
20	Bookends (pair)	T	20.00
20	Bookends (pair)	B	20.00
21	Child's Willow Tea Set	FP	250.00 +
23	Tea Set	FP	95.00
24	Miniature Teapot	TL	3.00
24	Miniature Sandwich Server	TR	3.00
24	Tea Set	B	40.00
25	Tea Set	T	100.00 +
25	Tea Set	B	50.00
26	Tea Set	B	50.00
27	Tea Set (miniature)	T	10.00 - 15.00
27	Tea Set (miniature)	B	10.00 - 15.00
28	Tea Set	T	50.00
29	Condiment Set	T	30.00 - 40.00
29	Condiment Set	B	25.00 - 30.00
30	Condiment Set	T	25.00 - 30.00
30	Mustard Pot	L	5.00 - 8.00
30	Mustard Pot	BR	5.00 - 8.00

* Some keepsake items were loaned for photographs and no "market value" was assessed.

31	Noritake Honey Pot	TL	*
31	Mustard Jar (Japan)	TR	15.00
31	Mustard Jar (Royal Bayreuth)	BL	65.00
31	Covered Bowl (slotted lid)	BR	15.00
32	Willow Salt & Pepper Set	TL	*
32	Willow Ashtray/Tip Tray	TC	*
32	Willow Salt & Pepper Set	TR	*
32	Willow Mustard Pot	BL	*
32	Willow Muffineer	BR	*
33	Cookie Jar	FP	65.00 - 70.00
34	Cookie Jar	T	65.00 - 70.00
34	Cookie Jar	B	65.00 - 70
35	Cookie Jar	C	50.00
35	Cookie Jar	B	50.00
36	Cookie Jar	T	30.00
36	Cookie Jar	C	20.00
36	Cookie Jar	B	20.00
37	Cookie Jar	T	40.00
37	Cookie Jar	B	20.00
38	Cookie Jar	T	25.00 - 30.00
39	Cookie Jar	B	25.00 - 30.00
39	Covered box	T	20.00 - 25.00
39	Covered Box	B	20.00 - 25.00
40	Cigarette Box w/ashtrays	T	25.00
40	Covered Box	C	10.00
40	Covered Box	B	10.00
41	Cigarette Box	T	10.00
41	Incense Burner	C	15.00
41	Covered Box	B	15.00 - 20.00
42	Cream/Sugar Set	T	25.00
42	Cream/Sugar Set	C	15.00 - 20.00
43	Cream/Sugar/Tray	T	15.00 - 20.00
43	Cream/Sugar Set	B	15.00
44	Cup/Saucer Set	T	15.00 - 20.00
44	Cup/Saucer Set	BL	15.00
44	Cup	BR	8.00 - 10.00
45	Cup/Saucer	T	10.00
45	Cup/Saucer	B	10.00
46	Cup/Saucer	TL	6.00 - 8.00
46	Cup/Saucer	TR	6.00 - 8.00
46	Cup/Saucer	CL	6.00 - 8.00
46	Cup/Saucer	CR	6.00 - 8.00
46	Cup/Saucer	B	5.00
47	Cup/Saucer	T	5.00
47	Cup/Saucer	BL	5.00
47	Cup/Saucer	BR	5.00
48	Cup/Saucer	T	8.00 - 10.00
48	Cup/Saucer	B	8.00 - 10.00
49	Snack Set	T	10.00
49	Snack Set	B	10.00
50	Donald Duck Band (each)	T	10.00
50	Scottie Dog Paperweight	B	15.00 - 20.00
51	Dogs (miniature)	TL	5.00 - 8.00
51	Dogs	TR	6.00 - 8.00
51	Dog (group)	BL	8.00 - 10.00
51	Puppy	BR	5.00 - 7.00
52	Dog (group)	T	6.00 - 8.00
52	Ducks (new)	BL	5.00
53	Tea Party Figures	T	45.00 - 50.00
53	Figurine	B	8.00 - 10.00
54	Figurine	T	15.00 - 20.00
54	Figurine (each)	B	20.00
55	Figurine	TL	15.00 - 20.00
55	Figurine	TR	10.00 - 15.00
55	Harlequin Figures (pair)	B	20.00
56	Cowboy/girl Figures (pair)	T	20.00
56	Figurine	BL	10.00 - 15.00
56	Figurine	BR	10.00 - 15.00
57	Dutch Figures (pair)	TR	20.00 - 30.00
57	Figurine	BL	25.00
57	Figurine	BR	20.00
58	Valentine Lady	TL	10.00

58	Cherub with Easel	TR	20.00
58	Jackie Coogan w/dog	B	40.00 - 50.00
59	Jackie Coogan (small)	TL	20.00
59	Small Children (each)	TR	15.00
59	"Dionne Quintuplets"	B	*
60	Flower Arranger	T	15.00 - 20.00
60	Flower Arranger	BL	15.00 - 20.00
60	Flower Arranger	BR	15.00 - 20.00
61	Lamps (pair)	FP	50.00
62	Lamp	L	15.00 - 20.00
62	Lamp	R	15.00 - 20.00
63	Lamp	L	15.00 - 20.00
63	Lamp	R	16.00 - 20.00
64	Figural Mug (lady)	TL	15.00
64	Toby	TR	15.00
64	Toby (pitcher)	BL	15.00
64	Tiny Toby	BR	10.00
65	Toby	TL	15.00
65	Accordian Player	TR	10.00
65	Tough Character	BR	15.00
66	Apprehensive Character	T	20.00
67	Mugs (each)	T	10.00
67	Mugs	B	10.00
68	Willow Farmer's Mug	T	*
68	Mugs (each)	B	10.00 - 12.50
69	Pincushion Holders (each)	T	5.00 - 8.00
69	Pincushion Holders (each)	C	5.00 - 8.00
69	Pincushion Holders (each)	B	4.00 - 6.00
70	Pincushion Holders (each)	T	4.00 - 6.00
70	Pincushion Holders (each)	C	4.00 -8.00
70	Pincushion Holders (each)	B	5.00 - 7.00
71	Pincushion Holders (each)	T	4.00 - 5.00
71	Pincushion Holder	C	10.00 - 15.00
71	Pincushion Holders (each)	B	6.00 - 8.00
72	Pitcher (large)	FP	45.00
73	Pitcher	T	10.00
73	Pitcher	B	10.00
74	Pitcher	T	8.00 - 10.00
74	Pitcher and Mug Set	B	45.00
75	Pitcher	T	8.00 - 10.00
75	Pitcher	B	20.00
76	Pitcher	T	35.00
76	Pitcher	B	8.00 - 10.00
77	Pitcher	T	8.00 - 10.00
77	Pitcher	B	10.00 - 15.00
78	Pitcher	T	5.00 - 7.00
78	Pitcher	C	5.00 - 7.00
78	Pitcher	B	10.00 - 15.00
79	Toucan Pitcher	T	20.00 - 25.00
79	Willow Pitcher	B	*
80	Planter	T	6.00 - 8.00
80	Planters (each)	B	6.00 - 8.00
81	Planters (each)	T	6.00 - 8.00
81	Planter	C	6.00 - 8.00
81	Planters (each)	B	6.00 - 8.00
82	Planters (each)	T	8.00 - 10.00
82	Planters (each)	C	6.00 - 8.00
82	Planters (each)	B	5.00 - 7.00
83	Planters (each)	T	5.00 - 7.00
83	Planters (each)	C	5.00 - 7.00
83	Planters (each)	B	5.00 - 7.00
84	Planter	T	5.00
84	Planter	C	5.00
84	Planter	B	5.00
85	Planter	T	5.00 - 7.00
85	Planter	B	10.00
86	Planter	T	6.00 - 8.00
86	Planters (each)	B	6.00 - 8.00
87	Planters (each)	T	5.00 _ 7.00
87	Planters (each)	B	5.00 ‾ 7.00
88	Planters (each)	T	6.00 ‾ 8.00

88	Planters (each)	B	5.00 - 7.00
89	Car Planter	T	10.00
89	Train Engine Planter	B	10.00
89	Cornucopia Planter	C	5.00
90	Swan Planter	T	5.00
90	Giraffe Planter	C	5.00 - 7.00
90	Swan Planter	B	5.00
91	Flower Pot	T	5.00
91	Art Deco dog Planter	BL	8.00
91	Fancy Shoe Planter	BR	10.00
92	Shoes (each)	T	8.00 - 10.00
22	Shoes (each)	C	8.00 - 10.00
92	Bootie	BL	4.00
92	Oriental Dish	BR	10.00
93	Cherub with Swan Planter	FP	15.00
94	Swan Planter	T	15.00
94	Swan, Horses and Cherub	B	15.00 - 20.00
95	Dog, Chariot, and Cherub	T	15.00 - 20.00
95	Pair of Swans, Planter	B	15.00 - 20.00
96	Planter With Elephants	T	15.00
96	Rectangular Planter	B	8.00
97	Round Planter	T	8.00 - 10.00
97	Square Planter, With Lions	B	8.00 - 10.00
98	Basket Planter	T	10.00 - 12.00
98	Oblong Planter	B	8.00
99	Bird With House Planter	T	9.00 - 10.00
99	Majolica-look Rooster	B	10.00 - 15.00
100	Double Planter	T	8.00 - 10.00
100	Small Flower Pot	B	3.00 - 5.00
101	Flower Pot	T	4.00 - 6.00
101	Flower Pot	B	4.00 - 6.00
102	Flower Pot	T	6.00 - 8.00
102	Hanging Flower Pot	B	10.00 - 12.00
103	Wicker-handled Dish	T	12.00 - 15.00
103	Tomato-shape handled server	B	20.00
104	Noritake Bon-Bon	T	15.00 - 25.00
104	Corn Set	B	45.00
105	Wicker-handle Server	T	15.00
105	Decorative Plate	B	15.00
106	Small Hand-painted Dish	T	5.00
106	Art Deco Dish	C	10.00
106	Plate	B	7.00
107	Plate	T	7.00
107	Plate (example of crazing)	B	no value.
108	Willow Bowl	T	*
108	Willow Place Setting	B	*
109	Clown Reamer	T	45.00 - 50.00
109	Clown Reamer	B	45.00 - 50.00
110	Clown-Head, floral Reamer	T	35.00 - 40.00
110	Reamer	B	20.00
111	Salt/pepper Shaker (each)	T	15.00
111	Butterfly/Flower Shakers	B	18.00 - 20.00
112	Tomato-Shape Shakers, Tray	T	20.00
112	Utility Salt and Pepper Set	C	10.00
112	Utility Salt and Pepper Set	B	10.00
113	Toby Teapot	FP	35.0
114	Elephant Teapot	T	45.00 - 50.00
114	"Stump" Teapot	B	25.00 - 30.00
115	Camel Teapot	T	45.00 - 65.00
115	Tomato Teapot	B	20.00 - 30.00
116	Tomato Teapot	T	20.00 - 30.00
116	Embossed Floral Teapot	C	35.00 - 40.00
116	Teapot	B	10.00
117	Teapot (if complete)	T	25.00
117	Teapot	B	10.00 - 12.00
118	Teapot	T	10.00 - 12.00
118	2-cup Teapot	B	6.00 - 8.00
119	Teapot and Cups	T	*
119	Matching Cream and Sugar	B	*
121	Elephant Teapot Set	T,B	100.00
122	Elephant Teapot Set	T,B	100.00
123	House Teapot	T	25.00

123	House Cream and Sugar	B	20.00
124	House Teapot	T	25.00
124	Cream and Sugar	B	20.00
125	House Teapot	T	25.00
125	Cream, Sugar, and Tray	B	25.00
126	Windmill Teapot	T	20.00 - 25.00
126	Windmill Teapot	C	25.00 - 30.00
126	Cream, Sugar	B	15.00 - 20.00
126	Salt and Pepper Set	B	10.00
127	Teapot	T	25.00
127	Matching Cups (each)	B	10.00
128	Teapot	T	15.00 - 20.00
128	Teapot and Cups (set)	B	65.00
129	Teapot	T	10.00 - 12.00
129	Teapot and Cups (set)	B	40.00 - 50.00
130	Tea Jar or Drippings Jar	T	8.00 - 10.00
130	Kitchen Items (each)	B	8.00 - 10.00
131	Clown Tea Bag Holder	T	10.00
131	Tea Bag Holders (each)	B	6.00 - 8.00
132	Toothpick Holder	L	10.00
132	Toothpick Holder	R	15.00
133	Mouse with Toothpick Holder	TL	15.00
133	Toucan Toothpick Holder	TR	15.00
133	Dog with toothpick Holder	BL	10.00 - 12.00
133	Duck with Toothpick Holder	BR	10.00 - 12.00
134	Toothpick Holders (each)	T	12.00 - 15.00
134	Matchbox Holder	B	35.00
135	Handled Vase	FP	20.00
136	Vase with Cherubs	L	25.00
136	Vase with Bird	R	15.00
137	Small Double Vase	T	10.00
137	Large Double Vase	B	15.00
138	3-Handled Vases (each)	T	7.00 - 10.00
138	Large Red Vase	B	35.00
139	Vase	T	7.00 - 10.00
139	Vase	BL	7.00 - 10.00
139	Vase	BR	7.00 - 10.00
140	Bisque Vases (each)	T	18.00
140	Small Vases (each)	B	8.00 - 10.00
141	Embossed Vase	TL	8.00
141	Vase With Applied Flowers	TR	8.00 - 10.00
141	Small Vases (each)	B	8.00 - 10.00
142	Dog and Vase	T	10.00
142	Vase with Applied Flowers	BL	12.50
142	Novelty Vase	BR	5.00 - 7.00
143	Wall Vases (pair)	FP	35.00
144	Wall Vase	T	15.00 - 18.00
144	Wall Vase	B	15.00 - 18.00
145	Wall or Shelf Vases (each)	T	15.00
145	Wall Vase or Planter	B	10.00 - 15.00
146	Basket Wall Vase or Planter	L	15.00
146	Floral Wall Vase	TR	15.00
146	Child, Floral Wall Vase	BR	15.00 - 20.00

Back Cover: Luster Vase with applied flowers 20.00

The back cover shows a typical 6 1/2" luster vase with applied flowers. Made in Japan.